CW00644572

MADE IN RUSSIA

Unsung Icons of Soviet Design

Rizzoli
NEW YORK

NEW YORK PARIS LONDON MILAN

Edited by Michael Idov
Text by Bela Shayevich

First published in the United States of America in 2011 by
Rizzoli International Publications, Inc.
300 Park Avenue South, New York, NY 10010
www.rizzoliusa.com

2011 2012 2013 / 10 9 8 7 6 5 4 3 2 1

Introduction © 2010 Michael Idov
Essays by Gary Shteyngart, Lara Vapnyar, Boris Kachka, Vitaly Komar © 2010 the authors

All photography © TASS-Photo unless otherwise specified below.
pages 15, 73, 132–133, 136–137, 139, 167, 169, 187 © RIA Novosti
pages 19, 24–25, 27, 37, 43, 67, 71, 79, 88–89, 91, 93, 131, 155, 179, 180, 181, 182, 184,
191, 215 by Olga Ryabceva
pages 29, 141, 143 by Lana Abramova
pages 33, 35, 192 courtesy Museum of Soviet Arcade Games
pages 68–69, 173 by Lily Idov
pages 82–83, 97, 183 © Lori Photo Bank
pages 104–105, 177, 178 by Ilya Popenko
pages 108–109 courtesy colormusic.ru
page 197 by Vasiliy Maksimov
page 217 courtesy IMZ-Ural

ISBN-13: 978-0-8478-3605-5
Library of Congress Catalog Control Number: 2010936343

Printed in China

Design as Dissent

Soviet consumer goods were the small-arms fire of the
government's relentless economic assault on the people.
Soviet consumer goods were an insult.

Clive James, *Cultural Amnesia*

I belong to the last generation that can reasonably call itself
"Soviet"—I was fifteen when the empire fell apart—and can
vouch for the fact that we grew up with some pretty terrible
stuff. Soda fountains with communal glasses, itchy clothes
in muddy hues, libido-quashing underwear. There were better
and brighter things, too, mostly made in East Germany or
Czechoslovakia, but the core of the Soviet consumer experience
was the same for decades. Nobody gave half a thought to
where these horrors came from or who designed them. They
had no provenance. You inherited them at birth, all at once.
They were part of life's kit, an ever-receding background noise.

And yet the great Clive James, quoted above, is not entirely
correct. If anything, Soviet consumer goods were the ultimate
advertisements for consumerism: Against this ocean of gray,
any item made with a modicum of care, the tiniest of formalist
flourishes, immediately shone out like a beacon. A Firmenny
(brand-name) cigarette lighter, an *importny* (imported) shopping
bag—no object was too mundane to crave if it was made well.
To live in the Soviet Union was not to be ignorant of good
design. It was to be obsessively, erotically hyperaware of it.

It took the Kremlin until 1959 to realize how starved for things
the nation was. In July of that year, Moscow's Sokolniki Park
hosted the American National Exhibition. (Now that was an
economic assault.) In just two weeks two million Russians had
had their faces mashed into a perfect tableau of Yankee
wealth. The Cadillacs, the TV dinners, the cosmetics, the denim!
The free Pepsi! Most notoriously, there was that cutaway model
of a suburban house (designed by the architect Andrew Geller),

where Nixon and Khrushchev stopped to spar in the famous "kitchen debates." But the Americans didn't just bring neat-o household gadgets. A dizzying array of names tagged along with the exhibit—Charles Eames, Buckminster Fuller, Frank Lloyd Wright, Walter Gropius. The country that had reduced all objects to pure function met the world's foremost experts on form. It had nothing to show in return.

Beet-red on that pastel stage set of a kitchen, Khrushchev told Nixon that the Soviets had better things to build—like the *Sputnik*. In reality, however, his humiliation was almost complete. The utopia took a massive hit: It was hard to argue spiritual superiority against the whir of an electric dishwasher. Something had to be done, lest morale disintegrate further. Having survived Stalin and the war, the people, it turned out, needed toys.

By 1962 the USSR's highest executive body, the Council of Ministers, came out with a thesis: "On Improving the Quality of Industrial Products and Cultural-Domestic Goods Through Implementation of Methods of Artistic Construction." These "methods of artistic construction" meant, for the lack of a term in the Russian lexicon, "design." The same resolution created VNIITE, the All-Union Technical Aesthetics Research Institute. By 1964, VNIITE had half a dozen branches and its own rather stylish magazine, *Technical Aesthetics*, whose distribution peaked at an impressive 30,000 copies.

It was also the Soviet Union's coolest place to work. Dmitry Azrikan, one of the country's first professional designers, has since described the magazine's publication as "an oblique form of dissent, all rooted in this typically 1960s belief that the Soviet socialism could have a 'human face.'" Like jazz or rock-and-roll fans, Azrikan and his friends found themselves "priests of an obscure cult," poring over dog-eared British and American trade magazines. Some of their work—like the sleek 1967 prototype of a gas station—was innovative by any contemporary standards. None of it ever saw production. "Our design wasn't even about design, per se. It was about showing how people lived on the

other side of the fence. I don't think any Soviet industrial designers ever expected their work to become reality: The manufacturers would never bother with any of our suggestions. So it was more like a public rebuke to the poverty of our surroundings."

The manufacturers, meanwhile, went down an easier road. They embarked on a long stretch of ripping off Western goods outright. The whole process was shockingly haphazard. A few times a year one Communist Party functionary or another would come home from a foreign trip toting the latest loot—a hair dryer, a vacuum cleaner, or, in the case of the mightiest few, a car. He would then show it to the engineers at the nearest factory: make one just like it. An orgy of reverse engineering ensued. While the elites at VNIITE drew elaborate technocratic fantasies for their own amusement and the rare international exhibit, their factory-bound counterparts, armed with strictly technical educations, did their best to duplicate the lines of a Vespa or a Hoover. Those who could draw were put in charge of logos, packaging, and other frivolities. Eventually the Soviets got their consumer goods. And they were weird.

Most had clear Western inspirations. A few were rip-offs so brazen, one suspects a kind of resigned black humor was at work: the makers of the Vyatka scooter, for instance, copied the Vespa down to the name and the font in which it was written, and then simply stuck a Soviet flag where the original bore an Italian one. Others, like the Buran snowmobile, were clever localizations. But something amazing happened along the way: An ineffable Russianness wriggled into each and every object. Even the Vyatka. In case after case, in ways clear and subtle, invention snuck in. The result was a kind of crazed Modernist pastiche. It jumbled together wartime know-how, space-age aesthetics, accidental shabby chic, Slavic motifs, and warped dreams of the West. This, not the celebrated Constructivism, was the true Soviet style. It remains recognizable at once. With the exception of the Lomo camera and the Kalashnikov rifle, it also languishes largely uncatalogued, unloved, and unsung. This style—Soviet magpie modernism—is what we celebrate here, in examples both sublime and silly. The book mostly

focuses on the 1960s and the 1970s because these two decades comprise the most active era in Soviet design: Once the initial burst of enthusiasm waned, the factories simply continued to churn out the same models well into the 1980s. Some are still being made to this day. In other words, here are the things with which the last three generations of Soviets grew up.

Which is why we also tried to put our show-and-tell into context. The objects in this book were not created equal, so they shouldn't be thought of as equal now. Some, like the *avoska* bag and Belomorkanal cigarettes, were considered low-class even by Soviet standards; others, like the Aelita-2 hair dryer, were sought after. The homely Zaporozhets sedan was the butt of endless jokes; the Ostankino tower, a source of fierce pride. You'll notice we threw in a couple of buildings, a few logos, and some ephemera—like the TV test pattern—that barely even qualify as objects. The idea was to trace one style through various surfaces of Soviet life, obvious and less so.

My personal relationship with the items in this book also varies. I was four when Misha the Olympic Bear briefly ruled the skies over Moscow, but I ate my most recent Clumsy Bear candy bar about three weeks ago. I've encountered some in the strangest places: It turns out that the halves of the globular Saturnas vacuum cleaner are much in demand among the medieval role-play crowd, since they make great helmets. Recently, I began bumping into nostalgic souls who've made it their mission to preserve these objects, at home or online. In fact, just before finishing this preface, I downloaded an obsessively reconstructed version of the 'Nu, Pogodi' game (see page 130) for the iPhone. The objective remained the same: to collect eggs falling from under the tails of six very prolific hens. It even made the same nauseating MIDI beeps meant to evoke the hens' clucking. I played it for a few minutes, with the sound off. I collected 182 eggs.

Michael Idov

Aeroflot

Logo of the Soviet national airline

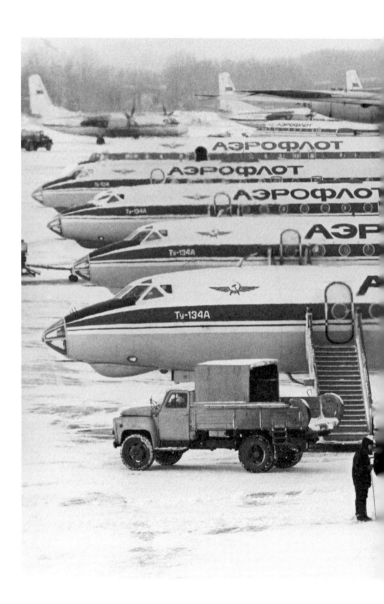

For those wishing to fly the friendly skies over the USSR, there was only one choice to consider, and it was Aeroflot. The company got its name (a classic Soviet abbreviation, albeit an unusually pronounceable one) in 1932.
A large sector of the Soviet economy in and of itself, it "represented the entire complex of Soviet aviation—cargo jets, helicopters, passenger planes, and so on. If it flew, it was Aeroflot. With this broad a range of activities, it quickly became the biggest airline carrier in the world.

Since the very beginning, Aeroflot was known by its sleek logo, colloquially referred to as "the little wings" or, sometimes, "the birdie." These wings were actually ripped off from a railway workers' emblem that had existed since 1894. The original emblem depicted the wheel of a train flanked by the wings of Mercury, representing speed, efficiency, and comfort in traveling. For the new logo, officials simply reinvented the wheel into a sickle and hammer. The wings literalized all by themselves.

While Aeroflot is no longer run by the state (though it is only "semi-private"), it has retained its status as Russia's national airline. In the 2000s, Aeroflot embarked on an image overhaul that included a revamping of the iconic logo. Surveys had shown that while Russian citizens were used to the omnipresence of signs of the Soviet past elsewhere in their lives, they were uncomfortable with this one. Millions of dollars were spent on a redesign by the British firm interUX. In the end, all of the proposed new logos were rejected: Aeroflot was reluctant to let go of a symbol that had represented the company for eighty years. As a result, the crossed tools of the worker and the peasant still greet the Russian air traveler from every napkin. The company did, however, finally change the boxy blue uniforms of their flight attendants, which, according to the same survey, passengers had found "revolting."

Sputnik

The first manmade satellite

If Soviet achievement has an icon, it's this simple shape, burned into a generation's memory: an elegantly whiskered orb. Following its launch on October 4, 1957, the *Sputnik-1* became the first man-made object to orbit the Earth. Though it was the size of a beach ball and did little more than beep, the satellite sent waves of pure wonder and terror over the entire planet. It arguably remains the pinnacle of the entire Soviet experiment. Typically enough, the *Sputnik*'s chief designer, Sergey Pavlovich Korolyov (1907-1966), wasn't acknowledged much during his lifetime: His very identity was considered a state secret.

The apparatus, officially named *PS-1* for *Prosteishii Sputnik* ("elementary satellite"), was indeed elementary. Its four antennae, each consisting of two parts (7.9 and 9.5 feet, respectively), were designed to transmit the satellite's beeps with equal power in all directions. The body of the *Sputnik* had a diameter of twenty-three inches and was constructed from two aluminum-magnesium-titanium coated hemispheres. Inside it hid a one-watt radio transmitter, a basic temperature and pressure regulation system, and three silver-zinc batteries. During *Sputnik*'s battery-powered lifetime, which lasted twenty-two days, it helped measure the upper atmospheric layer's density.

This last bit of science was but a fig leaf over a massive political mooning. The *Sputnik*'s real purpose was best summarized by congresswoman Clare Booth Luce, who described its beeps as "an intercontinental outer-space raspberry to a decade of American pretensions that the American way of life was a gilt-edged guarantee of our

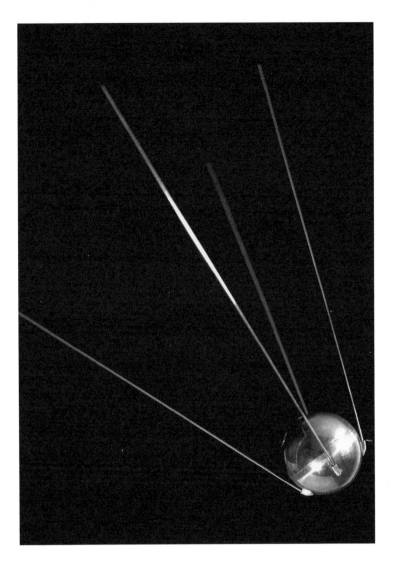

national superiority." Less than a year after the Soviets had sent it into space, President Eisenhower created NASA and poured hundreds of millions of dollars into the development of American science and engineering. *Sputnik* is credited as being the impetus for the creation of New Math.

Inevitably, it also jump-started a number of design trends. In the Soviet Union, the market was flooded with *Sputnik*-themed everything: commemorative postage stamps, key chains, teacup holders, paperweights, globes with *Sputnik* replicas attached to them on thin metal arms. Soon enough, all aspects of industrial design began to absorb its curves and headlong momentum. In the West it inspired the famous *Sputnik* lamps, polished chrome chandeliers that perfectly reflected the spirit of the space age—classic modern forms in bold and shining incarnations. Along American highways, neon starbursts and roto-spheres began to crown signs for roadside attractions—sometimes called "sputniks" by their manufacturers. Here's how far into the American consciousness has the shape has made its way: some see it in the famous star on the Welcome to Las Vegas sign.

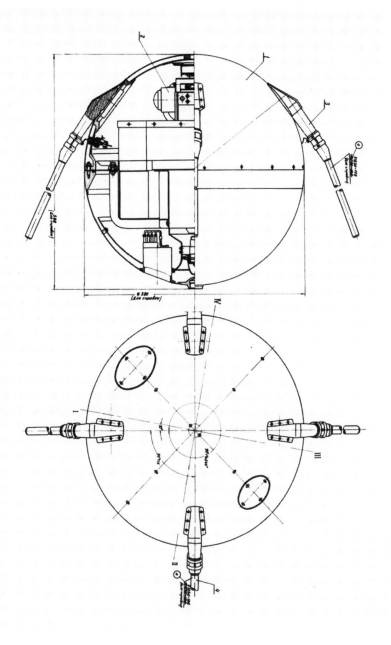

Aelita-2

Electric hair dryer

Since the publication in 1923 of Alexei Tolstoy's science-fiction novel *Aelita*, the name of its commie-loving Martian princess heroine has connoted otherworldly beauty with a progressive edge. The very following year a groundbreaking film by the director Yakov Protazanov cemented the image with its stark depiction of Aelita's desperate plight to escape a loveless (and gorgeously Constructivist) Mars to the sexy utopia of the Soviet Union. In a land with no brands, Aelita was a branding bonanza waiting to happen.

It took the advent of the actual space age to find a product fit for the name. In the 1960s it landed on one of the Soviet Union's first mass-produced—and largely unusable—electric guitars. In 1985 the Soviets found their Aelita once more, this time in an object perfectly combining the ideals of beauty, technology, and rock and roll: the blow dryer. It was the natural extension of a tendency to give domestic appliances that sound like rockets (i.e., vacuum cleaners) appropriately cosmic epithets. And with the huge, ABBA-inspired hairstyles popular in those days, they couldn't have chosen a name more fitting.

The Aelita-2 blow dryer came with a strap, a detachable hood (a ballooning hot pink helmet—perfect for forays into outer space), and an electric timer. It was manufactured in Moscow, but most ardently demanded, one suspects, in the provinces. Aelita-2s had only one setting—scorching hot—and soon, in dormitories and apartment buildings across the land, you could follow the smell of burning hair to the room of whomever was fortunate enough to own one.

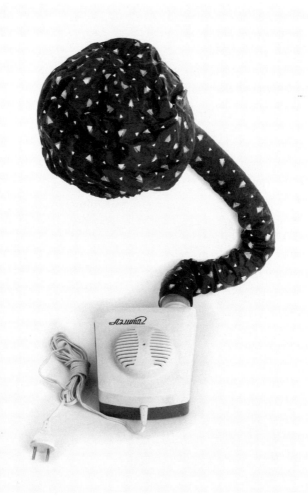

Space Mutants: The Evolution of a Symbol

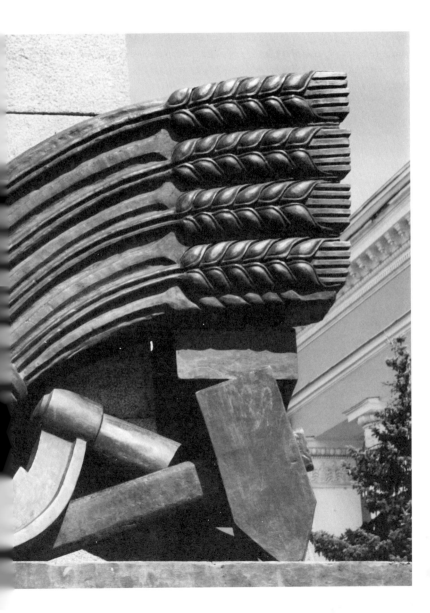

In the Soviet Union of the 1960s, the space race suffused everything. After the *Sputnik*'s launch and Yuri Gagarin's flight, every structure at Moscow's VDNKh fairgrounds—even the most prosaic ones, like newspaper kiosks and phone booths—was suddenly reaching for orbit. The effect on design was almost immediate.

Of course, the fashion for sleek aerodynamic forms had appeared ages before that. I first saw this style as a kid, in scale models of racecars that my parents had brought from Germany after the war. My guess is that these shapes originally appeared in illustrations to science-fiction novels, and then gained a fake but three-dimensional form in their film adaptations. (The little-studied phenomenon of sci-fi feeding back into life can shed some light on a lot of design mysteries, including how Art Deco came about.) What's most amazing, though, is that this space-age fashion overtook even the Soviet Union's very emblem: the hammer and sickle.

From the Sots Art point of view, the development of that icon is perhaps the world's most fascinating case of "ideological design." Creating a symbol of the socialist idea and the class unity between workers and peasants was not an easy task. One of its first versions was the Red Army emblem, which had images of a plow and a hammer inside a five-pointed star. The plow soon became a sickle, and the star drifted off on its own. The first official sketch, done by the artist Aleksandr Leo in early 1918, added a sword; but Lenin, who didn't want to scare the neighboring nations, convinced the Council of People's Commissars to remove it. Lenin was also the one to send the first official letter bearing the new crest on the seal—to Clara Zetkin in Germany.

The Freudian tinge of this story brings to mind the ancient, obvious reading of both the sword and the hammer as phallic symbols. As for the sickle—well, you may recall that the sickle in Greek mythology was a castration weapon wielded by the god of Time, Chronos himself. Since Communism was supposed to be the ideal coda to all human development, you could say that the crossed hammer and sickle represented the ultimate castration of history.

As time bore on, however, and history didn't end, the design underwent more tweaks and showed up in more variations. Among all the symbology of the USSR's early years, I am especially taken with the artist Ivan Puni's Cubo-Futurist take on the subject. Another interesting version was the state emblem of Uzbekistan, which swapped the sickle for a distinctly Uzbek tool that looked more like a sort of scythe. But, as I said, the symbol's most striking mutation happened after the *Sputink*.

In the agitprop of the late 1950s and 1960s, the sickle's edge began lengthening until it resembled a comet's tail—or a rocket's trail. Sometimes, at the very end of the edge, a hint of a "head" appeared, perhaps denoting a spaceship. Also, unlike Lenin, Khrushchev wasn't worried about intimidating the world with thrusting objects. Erected in 1964 right next to the VDNKh grounds, the *Monument to the Conquerors of Space* was so openly phallic that Moscow cabbies took to calling it the "Impotent's Dream." The upward-sweeping, titanium-clad, warhead-crowned plume metaphorically reminded the viewer of the sickle's secret ambition—to become a hammer. In the celebrated nearby statue by Vera Mukhina, *The Worker and the Peasant-Girl*, the phallic hammer is in the man's hands and on the right, while the sickle, symbolically a woman's attribute, is on the left.

The sickle's space-age reincarnation, and the lengthening of the edge that went with it, brought it closer to the very sword shape that Lenin had disiked so much. As an amusing side effect, this ruined the original emblem's gender balance: It now represented two crossed phallic symbols at once. Perhaps that's why I wasn't terribly surprised to see two male reliefs—one holding a hammer, the other a sickle—in that ultimate masterpiece of Art Deco: Rockefeller Center in New York City. Of course, it also couldn't help but bring to mind an infamous Soviet folk ditty of the 1960s:

Here's the hammer, here's the sickle,
Our nation's proud symbol.
Forge your steel or cut your hay,
You'll be buggered either way.

Vitaly Komar

Tembr 3

Wall-mounted electric radio

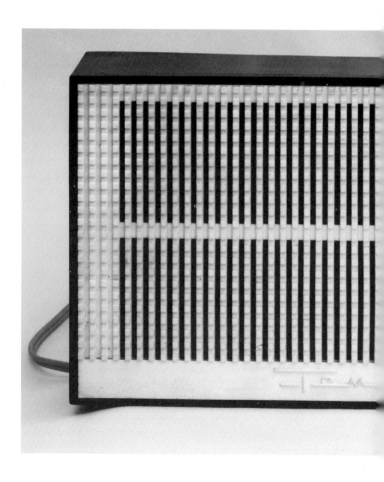

The Tembr 3 wire radio receiver was among the last of its
kind made in the Soviet Union. It was manufactured in
St. Petersburg in 1985 at a plastic consumer goods factory
called Plastibor, though the Tembr (meaning "timbre")

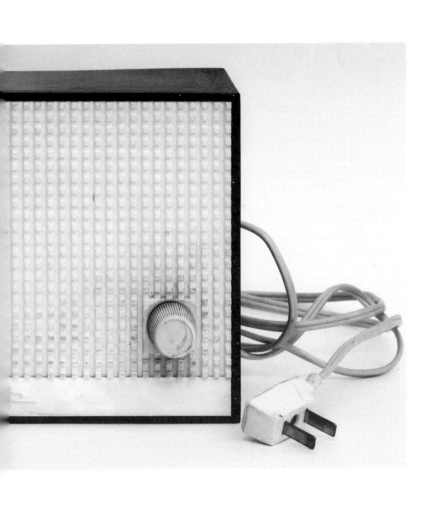

brand name had previously appeared on tape recorders produced elsewhere. Its rectangular shell is an homage to one idol: utility. Since the first wire radio receivers appeared in Soviet homes, their look was continuously simplified until all that remained was a small, stripped-down, easy-to-clean white box. It was meant to be mounted on the wall and disappear. After all, radios should be heard and not seen.

These *radiotochkas* (literally, "radio points") were designed to be always on. You couldn't turn them off, only down. In a state ruled by its own propaganda, radios constantly broadcasting the party line were considered an essential feature of the proletarian home. Their curse was also their one real virtue: Unlike televisions or regular radios, they could keep working even when there was no local electricity. This factor proved especially relevant during World War II, when the presence of *radiotochkas* in Soviet homes literally saved millions of lives in cities besieged by Nazis. In addition to providing citizens with information crucial to their immediate safety, the radios boosted morale and broadcast developments as they unfolded from the front lines. The medium's shining moment came when the official hiatus on musical broadcasts was interrupted for a performance of Shostakovich's Seventh Symphony from the devastated city of Leningrad in August 1942.

In peacetime, wire radios continued their rapid spread through the Soviet Union. Most apartment buildings that went up after the war came with wire radios preinstalled in the kitchens. By the 1970s the entire Soviet empire was tied together by its one national radio station; broadcast coverage for wire radios was universal. Reflected in numbers, there were eighty million wire radio outlets in the Soviet Union by 1990. Some forty-seven million remain today, souvenirs of a time when sheer simplicity of purpose—broadcast one thing twenty-four hours a day— led the Soviet designers to the heights of Apple-like monopoly and minimalism.

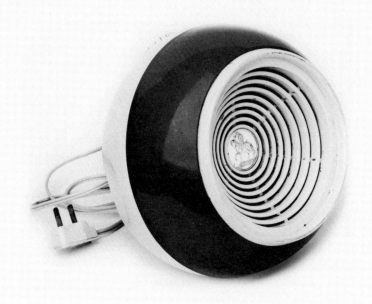

Temp 2

Television set

On New Year's Day in 1955, the Central Television Station—later renamed Channel 1—began, for the first time, to be broadcast daily. The channel had been created in 1951 as the first Soviet television network, but programming had previously been limited to a handful of shows in the evening. Ready to meet the expanding demands of televised propaganda was the Temp 2 television, manufactured in Moscow between October 1955 and December 1956. Along with the Avangard 55, it was the first television of its generation to come equipped with a dial that would eventually allow viewers to switch between five channels (that didn't exist yet) and three FM radio stations. But unlike the Avangard 55, the Temp 2 managed to do this without being streaked in pearlescent racing stripes.

The Temp 2 had an even larger screen than its predecessor, which had the largest screen of any Soviet television set. At the same time, it was only nominally bigger, though also about twelve pounds heavier. The Temp 2 looked out at its viewers from a polished wood cabinet, finished, as was the custom, to look like it was made from a finer kind of wood. The plastic frame around the screen came in an algae aqua or chocolate-milk brown, both rimmed in a rounded golden trim like a beautiful painting. Crowning this hodgepodge of ideas, materials, and illusions of grandeur were four ivory-colored dials symmetrically placed in the two lower corners of the television set. Temp 2 is a beautiful example of how, only a few short years before they wanted their electric devices to look as futuristic as possible, people dreamed that their personal silver screen would shine among their wooden furniture like a crown jewel in a china cabinet.

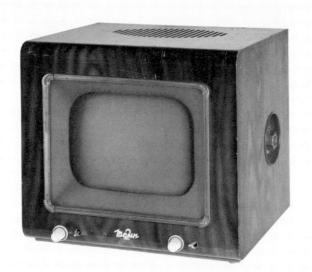

Television network test pattern

Before they spent their nights scamming insomniacs with
miraculous blenders, television stations used to sleep—just
like people. But unlike most people, before they were quite
asleep, stations emitted shrill screeches and wore mysterious,
geometrical masks. These noisy, mathematical-looking place
cards were the test patterns, and they also occasionally
flashed onto screens in between shows.

Television appeared in the Soviet Union in the 1930s
and steadily grew in popularity just as it did everywhere
else, except that, until 1960, there was only one channel.
Much of Soviet programming abused the long attention
spans of its viewers with endless parades of miners praising
their party secretaries, collective farmers elegizing their
tractors, steel workers delivering balanced critiques
of American foreign policy, and so on. While the Kremlin
might have loved it, it wasn't very popular with the kids.

Strangely, what kids did like was the test pattern. The sound
it made upset adults, and it was covered in fascinating
cryptic markings. (These were actually meant to allow
station production staff to calibrate their signals and cameras,
while also providing a test for viewers at home to check
how blurry the image was on their set.) The patterns were
the backdrop to long, meditative, dial-turning games,
playing with the look of the little smiling mustachioed
numbers man, winking back with his one eye. Sometimes
he was the only thing on the set with a sense of humor.

People even knew the test pattern by name: Tablet 0249.
When color television replaced Comrade 0249 with the
universally used color stripes, everyone was sad to see this
familiar fixture go. The only consolation was the fact that
they finally joined the rest of the world and got color TV.

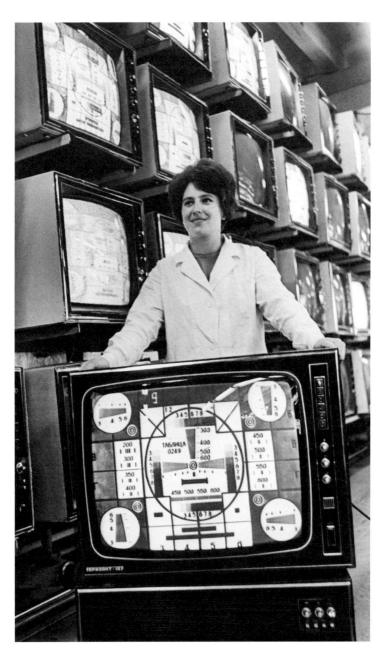

"Sea Battle" arcade game

The year 1974 saw the appearance of one of the first arcade
games in the Soviet Union, Sea Battle (Morskoi Boi).
Like the majority of the Soviet arcade games that would
follow, it had an older Western prototype; in this case the
1969 American-made Midway Sea Raider. Unlike its
inspiration, though, Sea Battle was not just a novelty for
overfed capitalists. According to the instructions, it was also
going to hone Soviet "visual estimation and shooting skills."

From afar, the game appears to be as complex as a submarine
itself, with its blue tin cabinet covered in mysterious,
bright yellow and red gauges. Upon closer inspection it
becomes apparent that this is just a box covered in stickers,
with a single moveable portion, the "periscope," and
just one button for shooting. The machines were said to
have been produced at an actual submarine factory,
an inadvertent comment on Soviet manufacturing. But this
free shooting practice didn't come to the people via the
Soviet military. The game was produced by the far-less-
threatening Committee on Amusement, a branch of the
Ministry of Culture.

Through the periscope, the player was taken into a kind of
minimalist diorama. Painted silhouettes of ships cruised back
and forth across a painted glass seascape—a less stylized

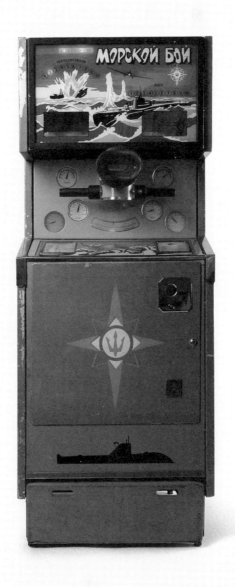

Battleship Potemkin on hand-tinted celluloid. Pushing the button would set off a slow-moving series of tiny red lights, symbolizing the trajectory of a torpedo, straight at the ships. Getting a hit resulted in a sudden change of lighting, accompanied by a flash of fire around the ship, and a "crashhhh" sound effect not for the faint of heart. While this all sounds very primitive and doesn't even qualify Morskoi Boi as an actual video game—more like pinball with lights—trying to get ten hits in a row was challenging enough to keep players hooked through the three consecutive times that the game allowed itself to be beaten before restarting.

After eleven years of letting comrades destroy defenseless ships, a modification of the game called Sea Duel was released in 1985. In Sea Duel, the enemy could strike back, an adaptation that afforded Soviet citizens a more realistic simulation of naval battle. The new game was warmly welcomed. Many years had passed since everyone had figured out that if you turned the periscope all the way to the right or the left and aimed at a ship just as it was finishing its voyage across the horizon, you were guaranteed a hit. But in the dreary and difficult Brezhnev era, you couldn't blame the people for taking easy shots and loving even the cheapest thrills.

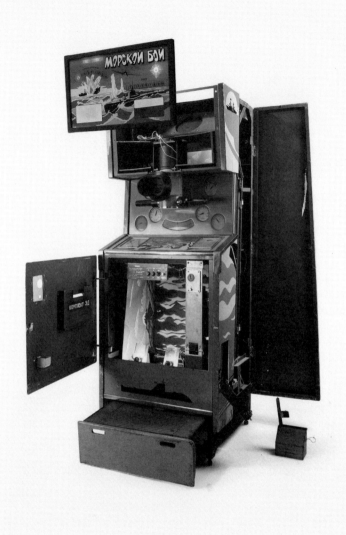

Erudit

Crossword game

The Soviets did not mess around with gibberish when renaming Scrabble for a localized version. They got straight to the heart of the matter: *Erudit*, erudite—if you're not good at this game, you're an idiot. Anglo-speaking Scrabblers were just mincing words. Educated Russians are too reverent of their language to be anything but direct.

Apparently, educated Russians also thought that Scrabble was too easy. The rules needed to be changed to better fit the rich tradition of Russian word games—manifestly superior word games. In Erudit, you can only play nouns in the singular, unless the noun has no singular, like "scissors," in which case it can be played in its plural form. That's how generous the rules of Erudit are: If there is only one way you can say a word, fine, you can have that word (but really you're a cheater).

Other adaptations had to do with the basic anatomy of Russian. There are thirty-three letters in the Cyrillic alphabet, including ten vowels and two mystery signs, so the letter and point distribution systems would need to be more elaborate. Erudit tiles were scored 1, 2, 3, 4, 5, 8, and 10. Obviously, there was some sort of complex mystical linguistic calculus at play.

And now the atom has split: Both a licensed Russian version of Scrabble and Erudit must coexist on the post-Soviet board games market. The boards fly their different but complementary palettes of restrained colors like feudal flags. Russian Scrabble tempts enthusiasts with an extra two points for the letter 'ё,' whose absence from Erudit is conspicuous (it is a controversial figure in the alphabet), and 104 tiles to Erudit's 129. Also, in Russian Scrabble, you can use any declination of any word you choose. But if you're a self-respecting Russian logophile, you won't.

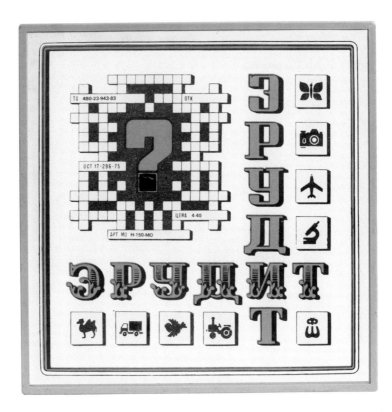

Street Soda Dispenser

Refreshment made communal

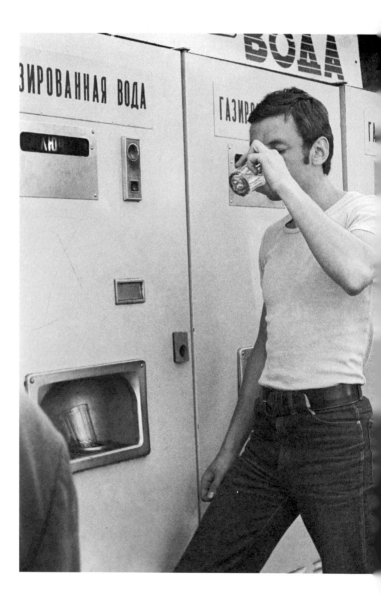

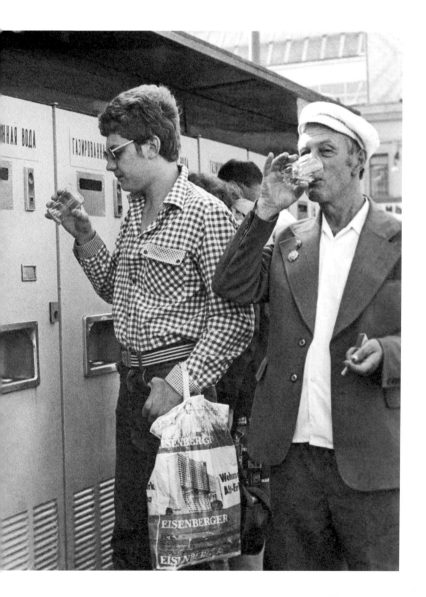

An article from the *Evening Moscow* dated April 16, 1932, proudly announces an amazing new Soviet innovation: the carbonator. Carbonators had been invented in Geneva two centuries previously, but one needed to be "installed in the Smolny cafeteria" for it to count. In the course of thirty years the Agorshkin machines—named after their illustrious inventor—were erected in countless grocery stores and eateries and operated by hand. Then, in the 1960s, after a trip to the United States, Nikita Khruschev decided that it was time to catch up with the rest of the world and make the machines automatic. It was only then that a real Soviet innovation appeared: the communal soda fountain.

The Soviet soda dispenser differed from its capitalist brethren by a characteristically gloomy design (in oatmeal gray) and a nice tall font to fit the long words "*gazirovannaya voda*" ("soda") across it. Refreshment came at one kopek for plain soda water and three kopeks for soda with a shot of syrup, a largely nominal price that miraculously held for decades. Every soda fountain held a classic twelve-paneled Soviet glass (see page 78), sometimes but not always chained to the grill underneath. After drinking your fill of delicious, carbonated tap water, you were supposed to place the glass upside down on a little fountain and press down, producing a jet that rinsed it out from the inside.

Getting free soda out of the machines became a national sport. There were many ways to do it: coin on a fishing line, the fake-coin maneuver, and the most primitive and surprisingly effective method of all—simply hitting it hard in the right spot. Advanced soda athletes, mostly children, invented ways to get extra syrup. Others found ways to hack the machines to get colder water out of them. All in all, it was an ethical as well as an hygienic disaster. In the 1990s, most of these abused metal cabinets were removed from the streets and sold as scrap metal to Estonia. The few that remain in markets and stores reflect the wisdom of post-Soviet capitalism. Practically Agorshkin machines, they are manned by attendants who dispense plastic cups and won't let you press the button yourself.

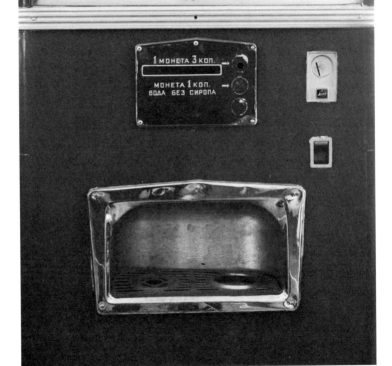

Collapsible Cup

Ultra-portable drinking vessel

In the Soviet Union, collapsible drinking cups were a common sight. Coincidentally, so were collapsed drunks. But they weren't the only ones who enjoyed emergency drinking vessels. The cup, an odd novelty in most other places, was an absolute necessity in the USSR. The thirsty Soviet may have had his choice of beverages—soda water from a machine, kvass from a barrel—but rarely, if ever, did these things come with a paper cup, let alone a plastic one. Like communism itself, disposable dishware existed only in theory. In practice, what was available to the masses was the highly suspect communal drinking glass. The collapsible cup was thus a telescopic beacon of hope in an icky world of strangers' germs, and a modest triumph of individuality to boot. This could also account for why it was very popular as a souvenir. Finally, it was a neat toy: You could slowly extend it upward ring by ring, in a process we can imagine looked similar to the construction of the Guggenheim museum in New York City, and then—bam!—flatten it with one slap. If you did this too many times, however, the concentric rings tended to come a little loose, and liquid began to bead on the outside of the cup. Then it was time for a new one. Luckily, they cost next to nothing.

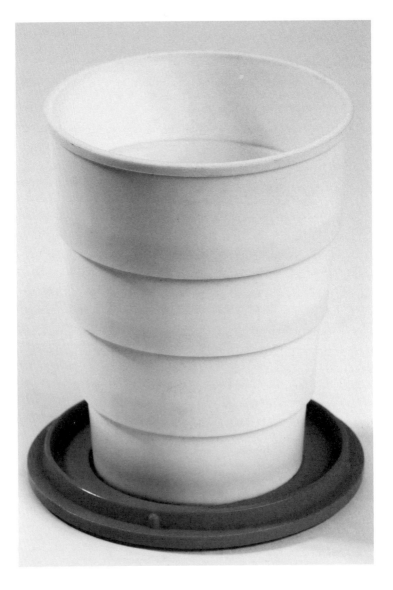

Change Machine

Metro coin dispenser

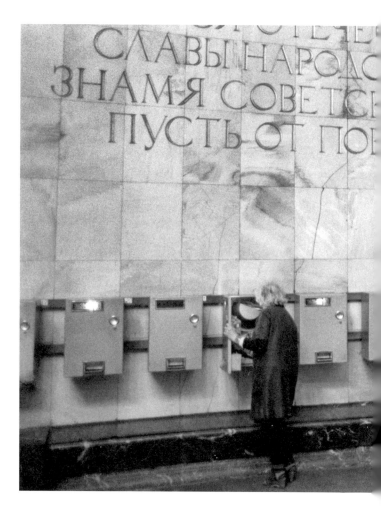

In a book on the Soviet subway system published in 1934, which celebrated the wonder-to-be a year before its first station would open to the public, the authors describe how commuters will have access to the trains at the drop of a token.

In reality, attendants were responsible for selling and collecting passengers' paper tickets until 1959. Despite the fact that trains come very often (every ninety seconds, today), the Moscow Metro, which carries the second-highest volume of commuters in the world, has always been incredibly crowded. One can only imagine the lines behind the ticket booths before the promised coin-operated turnstiles were finally installed in every station in 1961.

That year was also one of monetary reform: Old rubles were exchanged for new ones at the rate of ten to one. The cost of a trip on the Metro, which had been stable since 1947, went from fifty kopecks to five. The new turnstiles were built to accept five-kopeck coins—real tokens wouldn't appear until the fall of the Soviet Union. And since not enough people had them handy, the Metro was forced to create and install a whole new breed of coin-exchange machines.

Excitingly, the machines came in five colors: natural metallic gray or bright yellow, green, red, or blue. Each color denoted the kind of coins the machine would accept—yellow ones only gave change for ten kopecks, red ones for twenty, and so on. Functionality aside, the very idea was a hip rebuke to the solemn Stalinist-deco interiors of the Metro. The Soviet subway stations were never fully modern: They were a weird mix of nineteenth-century opulence and Communist iconography. By contrast, the machines—candy-colored, with smooth rounded edges—were pure modernity. They wouldn't have been out of place at Idlewild.

Because the fare didn't go up for the rest of the Soviet era, the coin-exchange machines stuck around for decades. By the 1980s they didn't stick out as much, but were quietly beloved nonetheless. Today, expert nostalgists report that the sound they made—the closest the Soviets came to cha-ching—was among the most wonderful of the era, now lost forever. Indeed, it's hard to imagine that the beep of a smart card against a magnetic reader could ever inspire the same fluttering of the heart as the ringing cascade of copper.

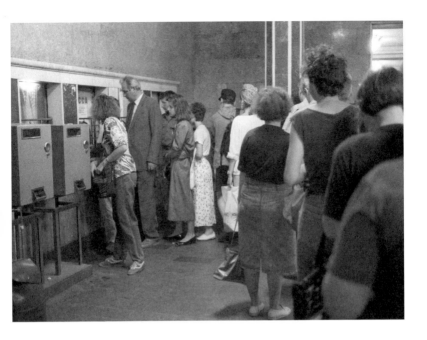

A selection of *Technical Aesthetics*
(*Tekhnicheskaya Estetika*) magazine covers,
published between 1973 and 1991.

техническая эстетика

7/1979

ISSN 0136—5363

техническая
эстетика 1973 7

техническая
эстетика 1974 2

№ 5 (329) 1991

№ 11 (335) 1991

техническая эстетика
9/1986

№7(319)1990

техническая эстетика 2 1990

техническая эстетика 1/1987

№22(326)1991

техническая
эстетика 1974 8

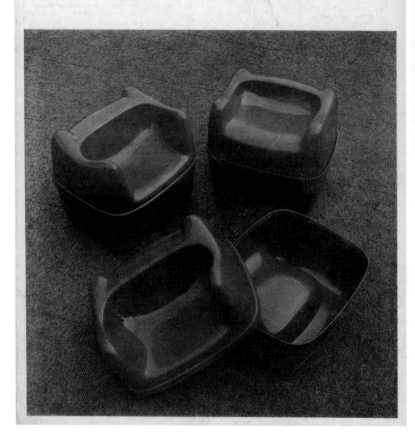

техническая
эстетика

5

техническая
эстетика
2/1979

ISSN 0136—5363

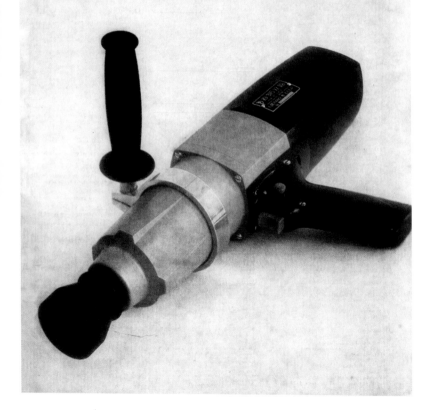

техническая эстетика 1 1990

FUTURO
DESIGN
ФУТУРО
ДИЗАЙН

техническая эстетика
4/1986

техническая эстетика
8/1986

Т Е Х Н И
Ч Е С К А
Я З С Т Е
Т И К А
1 9 8 6

техническая
эстетика 8

1975

техническая
эстетика 1975 12

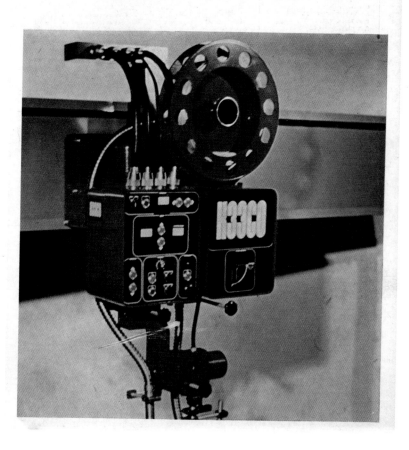

техническая
эстетика
7/1989

техническая
эстет...
2/1989

техническая эстетика
3/1985

техническая эстетика
9/1985

техническая
эстетика

ISSN 0136—5363

6/1979

техническая
эстетика 1974 7

СССР — ГДР

РОЛЬ ХУДОЖЕСТВЕННОГО
КОНСТРУИРОВАНИЯ В
РЕШЕНИИ КОМПЛЕКСНЫХ
СОЦИАЛЬНО ЗНАЧИМЫХ
ЗАДАЧ ПРОЕКТИРОВАНИЯ
ПРЕДМЕТНОЙ СРЕДЫ

ISSN 0136-5363

техническая
эстетика
12/1979

ISSN 0136—5363

техническая эстетика
3/1979

Reflector

Aluminum space heater

It will come as no great revelation that most Soviet apartments had heating issues. What's more interesting is that a popular way of dealing with these issues was to have a naked red-hot spiral perched next to, say, a baby's crib or a billowing synthetic curtain. Meet the USSR's greatest fire hazard: the so-called "reflector space heater." Popular throughout the 1970s, these shiny household arsonists were made of aluminum, tin, and plastic. Their modern look belied their primitive construction, which was almost noble in its idiocy. The heater consisted of an infrared bulb in a ceramic socket, a metal spiral wound around it, and a dish designed to radiate the resulting heat, like a broadcasting signal, into the room. In reality the warmth produced by these things was narrowly focused and campfirelike (your nose would sizzle as your ears froze) and massively outweighed by the obvious risks. In later generations the spiral itself came encased in glass for a supposedly gentler kind of heat. While we haven't seen one on sale in modern Russia, in provincial stores you can still come across replacement spirals—which suggests that enough Soviet-era space heaters remain in working condition or even, more frighteningly still, in use.

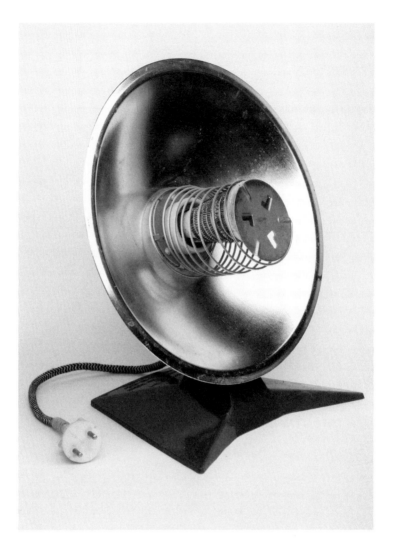

Belomorkanal

Papirosa cigarettes

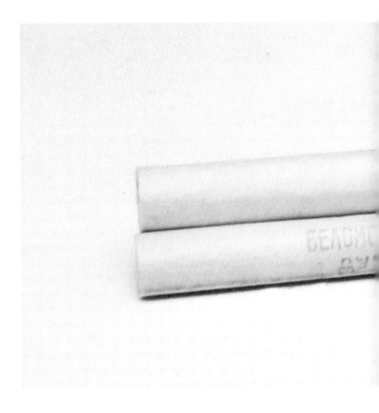

Belomorkanal, or Belomor, is a terrible cigarette and an amazing memento mori. The brand was created in the late 1930s to commemorate the completion of a 141-mile canal that connected the White Sea (*Beloe more*) with the Baltic. It was the first major Soviet project to use forced labor, and an estimated one hundred thousand prisoners died during its construction. Only the bleakness of this backstory could make Belomor seem any less bleak in comparison.

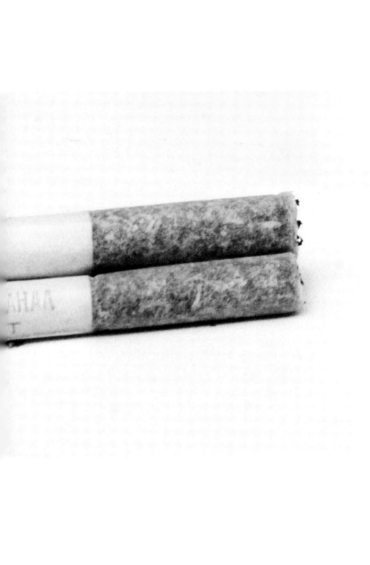

Belomors are *papirosas*, a decidedly obsolete form of
cigarette that is meant to go out when not being puffed.
Each is essentially a roll of cardboard wrapped in nearly
translucent paper that also contains about an inch and a half
of what seem to be the sweepings from a long-abandoned
tobacco factory floor. The stems and scraps portion
comprises only a third of the length of the cigarette; the
cardboard "filter," which is just a hollow tube, is meant
to be pinched into something like a cigarette holder in
order to protect the smoker from the shrapnellike substances
they are about to put in their lungs. Outside of a prison
camp, the Belomor is probably one of the worst things that
man has ever smoked.

The packet itself, however, is a different beast altogether.
It is, without a doubt, one of the triumphs of Soviet
commercial design, as iconic in its severity as the stars over
the Kremlin. Designed by the artist Andrey Tarakanov,
the pack originally depicted the Belomor Canal alongside
the Suez and Kiel canals, both of which it dwarfed.
In 1952, after the completion of the Volga–Don Canal
(also constructed by prisoners), the pack was redesigned in
order to solely reflect Soviet achievements in canal building.
It's seen new lives as a rock-and-roll record cover and,
in the late 1980s, a widely reprinted anti-Stalinist poster that
imagined thousands of chained men spilling out of it like
tobacco crumbs.

Today, Belomors continue to be manufactured in
St. Petersburg, and cost a little less than a fifth of the price of
a regular pack of cigarettes. While still smoked by the very
old and the very poor, Belomors have also found a new
demographic: potheads. Marijuana users remove the tobacco
(sometimes simply blasting it out of the paper like a blow
dart), and then replace it with weed (sometimes sucking it
up through the tube). The result is called *raketa*, or "rocket."
The Russian police have caught on to this use of the
cigarette and have been known to detain middle-class-
looking youths as soon as they buy a pack. Belomorkanal:
It can still mean hard time.

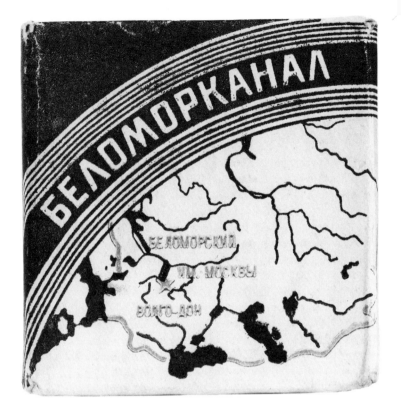

Avoska

Cotton fishnet shopping bag

In every Soviet handbag, and in many a trouser pocket, hid a hopeful little bundle that could expand to fit almost any shopping dream come true. The *avoska*, a simple net bag, allowed citizens to be always prepared in case they crossed paths with something extraordinary—like fresh produce. It was also remarkably Soviet in affording the shopper zero privacy: One's loot was on instant and automatic display.

The design was developed during the 1930s, when severe food shortages were the norm. *Avoska* is a typically resigned joke on the word "*avos'*," which is a sort of "perhaps" biased toward a "god willing"—a secular Russian *inshallah*. People carried their little net bags hoping for the small miracle of finding something to put in them. After the war, as food production became more stable, the "god willing" developed into a less urgent "just in case." From the 1960s onward, Soviet retail would produce irregular and brief outcroppings of exotic goods, which required lightning-quick reactions and the *avoska*'s near-endless capacity.

In the early to mid-1980s, the Soviet Union enjoyed its first exposure to supermarket-style plastic bags; it was not a rare sight to see them hanging from clotheslines, washed and ready for reuse. The "best" kind—with hard plastic handles that snapped together—were by themselves a sign of access to Western goods. The *avoska*, conversely, became a kind of antistatus symbol, a reputation that plagues it even today (when it could conceivably be recontextualized as green chic). In the West, organic cotton net bags telegraph their owners' eco-consciousness. By contrast, the *avoska*, woven of coarse synthetic fiber that cuts into the skin, is still avoided in Russia as a relic of poverty. No matter how simple and ingenious the design, people no longer want to carry their hope around in a collapsible bag.

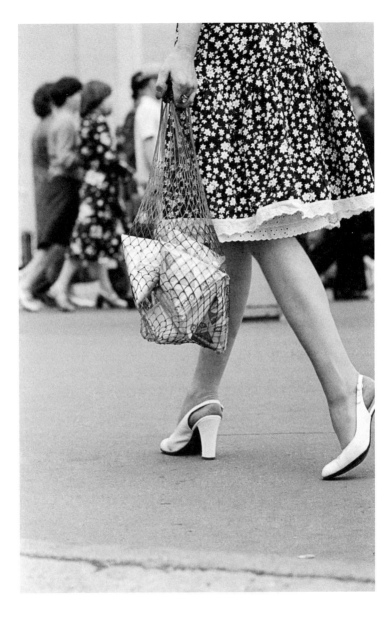

Pyramid Milk Carton

Second life of Tetra Pak's first hit

One common Soviet phenomenon was a Western design's finding a much longer shelf life there than it did in its homeland. The passionately beloved pyramid milk carton is a good example of this. It was the very first produced by the international food-packing giant, Tetra Pak, founded in Sweden in 1951. The tetrahedral package that gave the company its name was designed by Erik Wallenberg and came to be called the Tetra Classic. The brilliance of this design was that it wasted no materials while producing a container that allowed for easy storage and transportation. The cartons were formed out of a single tube of paperboard that was sealed as it was filled with milk. This also meant that the machines manufacturing these cartons were capable of working continuously. In essence, they were the designer's dream come true: a packaging concept that saved more money than it cost to implement.

In 1959 these wonder cartons appeared in the Soviet Union. The economy of producing them soon led to the disappearance of glass bottles from shelves. In 1961, Tetra Pak had already moved on to packaging milk in rectangular containers. In Russia, however, the pyramids had astonishing staying power. They stuck around for at least thirty more years.

This was partially due to the simple fact that the Russians had no plastic shopping bags. It seems that one of the biggest problems caused by the pyramid cartons was that their sharp corners shredded most shopping bags. Meanwhile, in the Soviet Union, the pyramids simply poked out of the apertures of the fishnet *avoskas* (see page 72). The real

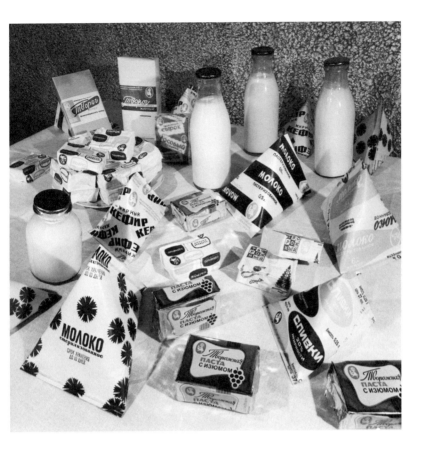

problem was that the cartons tended to spring very slow leaks. Sneaky shop-women would then give these messy cartons a quick wipedown and try to foist them on unwitting customers. As usual, citizens had to be vigilant.

The cartons in the Soviet Union were filled with every imaginable Russian dairy product—simple milk, kefir, rich cream. While for the most part the food situation in the Soviet Union was deplorable, when it came to dairy, things were not as bad as with other essential food groups. Smaller pyramids were distributed to schools, where children were told that drinking milk would give them the jumping capabilities of Yuri Gagarin, the first cosmonaut. Though the physics of this fell short, the propaganda was effective. People drank all the fresh milk they could, and turned sour milk into various cultured concoctions at home. Empty pyramids were used as storage containers for small household items, and even as planters.

In post-Soviet Russia, juices and soda have cut into milk's popularity: Dairy consumption in Russia has decreased by almost one-third since 1991. The country has finally taken advantage of the technology created by Tetra Pak in the early 1960s, which allows antiseptic milk to be stored for up to six months without any need for refrigeration— in rectangular cartons. The fondly remembered little pyramids are, alas, no longer an option.

Beveled Glass

Still-ubiquitous Soviet classic

The Soviet sculptor Vera Mukhina is most famous for her 1937 monument *The Worker and the Peasant-Girl*. When that statue was restored in the early 2000s, it was jocularly suggested that the hammer and sickle clasped by the two great figures be replaced with Mukhina's other, equally iconic creation: the twelve-sided drinking glass. The joke was apt: The paneled glass is as familiar to the Russian hand as it was dear to the Soviet heart.

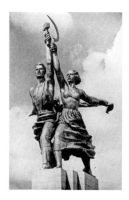

First mass-produced in 1943, the glass was designed for durability. It would hold up not only to the clumsy or passionate toast, but to the industrial dishwashers developed in the 1930s. Which is not to say that it wasn't also good-looking; some attribute its clean lines and satisfying proportions to the influence of the constructivist painter Kazimir Malevich.

Despite its illustrious parentage, whatever it may be, the glass isn't celebrated for its form alone. Never before and perhaps never since was a single drinking vessel as prevalent.

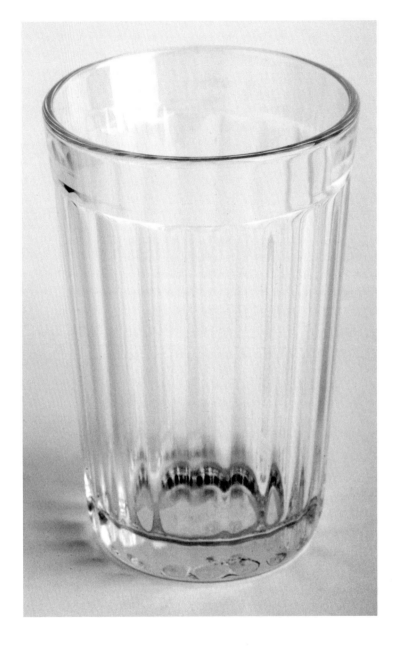

After the Second World War, five or six hundred million glasses were produced annually—enough for each Soviet hand, both left and right. They were filled with every possible liquid: hot tea in the dining cars of trains, warm milk in the nurseries, god-knows-what in the prisons, imported cognac in the offices of the Kremlin, and vodka everywhere.

The glass became an example of how industrial design and politics can coincide to shape society. During his reign, Nikita Khrushchev banned 250- and 125-gram bottles of vodka in an effort to combat alcoholism. They were replaced by the 750-gram bottle—just enough vodka for an even three glasses, which happened to hold exactly 250 grams each when filled right up to the rim. Two questions became the password to every drinking party: "Want to be the third?" followed by the essential, "Got a glass?" The expression "*ostakanit'sya*," a verb meaning literally "to glass up," came to be used as slang for drinking. The glasses evolved into such an important element of the drinking ritual that when a shoddily manufactured batch started spontaneously bursting across the country in the early 1980s, a rumor blamed it on the newest, most insidious state anti-alcoholism tactic yet.

These days, the classic glass is still produced at a factory in the aptly named town of Gus-Khrustalny (Crystal goose). However, a remarkable lookalike, in three sizes, has proliferated in IKEA stores worldwide. And if you drink up, you will see the words "Made in Russia" engraved on the bottom of each.

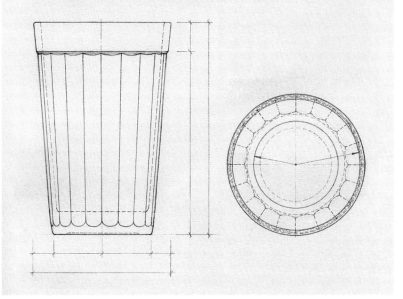

Kvass Barrel

Mobile malt drink station

Kvass, a fermented beverage made of dark glutinous rye, appeared to the Slavs a year after Christ did. The first written record of it in Russia dates from the year 989.

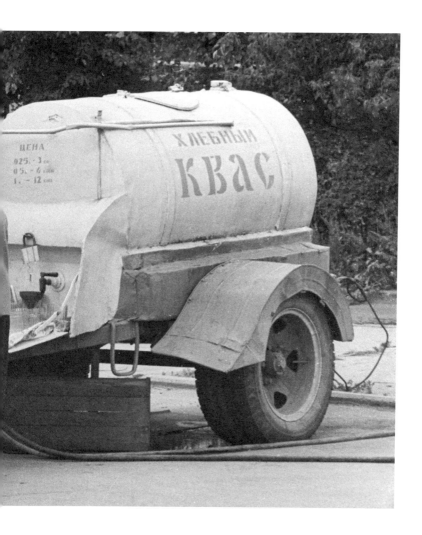

In the nineteenth century, it was the most common nonalcoholic drink (though it does contain a small amount of alcohol), and it was reported that monks drank more kvass than water. It tastes like a sweeter *kombucha*, which you could anticipate upon etymological inspection of its name: the word "kvass" comes from the Polish "*kwas*," meaning "acid." The stuff is sour, bready, and best enjoyed very cold.

In the mid-1960s, automatic soda dispensers (see page 38) and Brezhnev's historic deal with Pepsi were still in the future. For now, the Russian national beverage—okay, its other national beverage—was the perfect candidate. In 1967 two factories began producing special barrels that would be capable of delivering large quantities of kvass to the masses. The barrels had been designed ten years earlier, and were known as "tanker-cistern trailers," for transporting milk. They held nine hundred liters of liquid, were properly insulated, and came on wheels that looked like they could make their way through their share of muck. Nobody knows where their shade of yellow, as piercingly particular as that of New York's taxicabs, came from. But for the next twenty-five years in the USSR, this was the color of summer.

The kvass backlash came with the fall of the Soviet Union—and lasted about as long as the Russians' initial enchantment with all things Western. In the early 2000s, be it by popular demand or Putin's decree, the barrels were repaired, repainted, and made their glorious way back onto street corners. In some cities, vendors even had the common sense to make smaller kegs painted the same color. Loving kvass became a way of reclaiming a sense of national pride, and kvass consumption increased astronomically. According to one report, sales grew by 1520% yearly from 2001 to 2009. Numbers aside, kvass's resurgence in popularity even made Coca-Cola jealous. The company has begun making its own kvass for the Russian market, with Pepsi hot on its heels to catch up to the thousand-year-old craze.

Caviar Tin

Color-coded delicacies

While it has long been considered noble fare, Russian peasants have been eating caviar since at least the eighth century. When it was first presented to Louis XV by Peter the Great, the king famously spit the offering onto the oriental rugs of Versailles. However, by the nineteenth century, Russia began exporting the stuff in earnest, and Europeans began acquiring a real taste for it. Exiled Russians who found their way to Paris after the revolution in 1917 brought their love of sturgeon roe with them. In an ironic turn, the fashion for their bourgeois predilection greatly benefited their proletarian enemies. Soon enough, the Reds gained a near-monopoly on the highly lucrative caviar trade.

Before the revolution, caviar was transported in wood barrels. The Soviet-produced "Russian caviar" came in tins color-coded for their contents. Beluga, the rarest and most expensive variety with the largest grain, came in robin's-egg blue. Osetra and the least expensive Sevruga variety came in yellow and red, respectively. Whoever made that choice unwittingly cemented a design tradition that will soon turn a century old: No matter its provenance, almost all caviar in the world still comes in tins of these particular shades.

Though the Soviet government was notorious for its callousness toward natural resources, its control over caviar production was actually tempered with an eye toward sustainability; a twelve-year prison sentence was the penalty for poachers. As soon as the Soviet Union fell, sturgeon fishing spiraled out of control, and in 2007 the harvesting and sale of black caviar was banned in Russia. Iran and the US are finally having their day on the market. Regardless, the Soviet caviar labeling system—blue, yellow, red—remains in place, a relic of a time when the world's fanciest food came from the great Socialist nation.

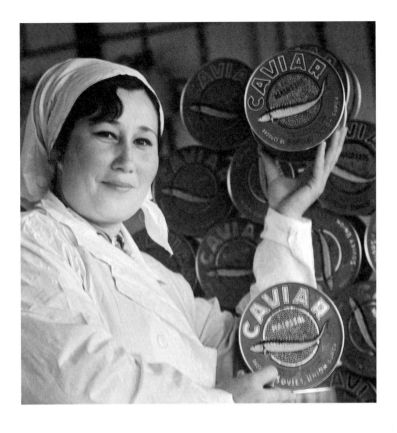

Raketa, Chaika, Saturnas

Space-age vacuum cleaners

No household item is a better candidate for a space-kitsch makeover than a vacuum cleaner. This idea was taken to new heights after the launch of the *Sputnik*, when the spoils of the space race littered the worldwide domestic goods market like so much satellite debris. In the early 1960s you could find almost any household item designed to somehow incorporate the idea of intergalactic travel. Ahead of the curve, vacuum cleaners had already been going in this direction for a while.

The brand name Raketa, or "rocket," appeared irresistible to the space-mad Soviets: They bestowed it on a type of river vessel that launched in 1957, a wristwatch introduced in 1966 (see page 92), and a myriad of other things. The Raketa vacuum cleaner, though, predated actual space travel by a good while. It first appeared in 1953.

While it was produced on the relatively ancient prototype of the 1924 Electrolux Model V vacuum, a sleeker frame with chrome details and a brilliant aqua-colored body placed it firmly in its own era. Raketas may not have been able to go as far or fast as their aerodynamic curves and powerful roar would have you think, but they were durable, well-made machines with surprisingly long shelf lives. Models in perfect working condition can still be found today.

But the Raketas' red glare paled before the Saturnas. The globular Saturnas was, surprisingly, based not on the famous shape of the *Sputnik* but on the amazing 1952 Hoover Constellation vacuum cleaner. In many ways it was an improvement. Instead of the "hovering" gimmick (the Constellation blew air down to the floor, which supposedly made it weightless), four little wheels were mounted on its beautiful blue form—a planet of two halves joined at the center by a bone-colored ring. Interestingly, Saturnas's core contained no concentric vacuum bag for holding in the dust, and cleaning it out was presumably a messy affair. It was manufactured in Lithuania from 1962, which explains both its name and its quality. The Baltic republics, closer to the edge of the iron curtain, were known to produce better made, sexier, and consequently more expensive products than their eastern Soviet counterparts.

The Lithuanian chic of the Saturnas has extended into a rather fantastic afterlife. As is the case with the Raketa, it takes a lot to break the Saturnas. This is why these vacuum cleaners stuck around long enough for a whole new brand of geekery to spread through post-Soviet Russia: Gamers of the live-action role-playing variety now use the top hemispheres of the Saturnas as medieval helmets.

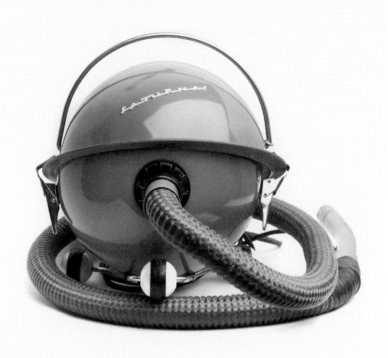

Wristwatch

The legends surrounding Raketa ("rocket") wristwatches speak volumes. Waterproof, it can still tell the time from inside a full flute of champagne. Sturdy, a Raketa wristwatch once shattered a television screen it was angrily thrown at, and remained unharmed. Durable, a Raketa was found still ticking in the belly of a freshly caught pike. And the real story of the Soviet Union's most popular watch is no less legendary.

Raketas were manufactured in one of Russia's oldest and most revered institutions. In 1721, Peter the Great created the Peterhof Lapidary Works, whose masterpieces of marble and precious stone were world renowned for their beauty and craftsmanship, up to the beginning of the twentieth century. But the Soviet people wouldn't need splendorous marble creations, and in 1932 the Peterhof Lapidary Works was renamed the Factory of Precise Technological Stonework and began to cut jewels for use in the watch industry. From there it was one short step to producing its own line of wristwatches.

The immediate predecessor to the Raketa, the Rossiya, was the factory's first independently designed watch. Developed by a team of engineers led by Mikhail Kiselev and Ivan Starkov, it had a new shock-resistant mechanism and a twenty-four-hour dial. Its production stopped in 1962, just when the Soviets were actively expanding their horizons into space, aviation, and polar exploration. The times demanded a watch that could survive in extreme conditions on the wrists of explorers, sailors, pilots, and—why not?—cosmonauts. In 1966 the factory came up with the Raketa, a name that has stuck to every watch it has produced since.

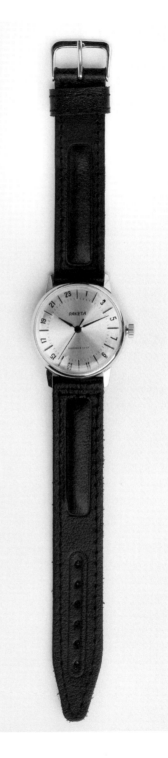

The Raketa was a beauty: only 2.7-mm thick, dust-
and moisture-proof, waterproof, and antimagnetic.
Assembled from stainless steel, the watch came plated in
chrome and gold, and styled with a very Soviet seriousness.
Hundreds of models appeared over the next three decades,
ranging from sleek and heavy world time zone watches
for Party jetsetters to cheap-looking propaganda pieces with
gaudy red sickles and hammers for schoolboys. They were
somewhat expensive but also, as far as Soviet goods went,
genuinely chic.

In 1977 the brilliant minds and careful hands behind the
Raketa stepped away from the conveyor belt. They had built
machines to replace themselves: The factory became the
first in the world to produce watches on a fully automated
assembly line. It continued to prosper into the 1980s,
growing into an entire compound complete with a medical
center, a stadium, and summer camps for the children of
Raketa's six thousand employees. Only the end of the Soviet
Union and the consequent appearance of cheap watches
made by those other Communists, the Chinese, could
bring the factory back down to Earth, where it proceeded
to go bankrupt. The 1990s market was consequently
flooded by fake Raketas—a rare case of a Soviet item
meriting a knockoff—many of which still bore the
anachronistic "Made in USSR" inscription, now a kind of
perverse marketing hook.

Since 2004, Raketa has been broken into two companies.
One, owned by the French count Jacques von Polier, still
manufactures watches and has lately taken welcome
inspiration from the original 1960s designs. The other simply
rents out parts of the old factory. Still, the three hundred-
year-old institution has left behind quite a legacy. As antique
marble pieces from the old Lapidary Works continue to
dazzle visitors to the Hermitage, Raketa wristwatches will
keep ticking, whether they're frozen in icebergs, swallowed
by whales, or just sitting on someone's wrist.

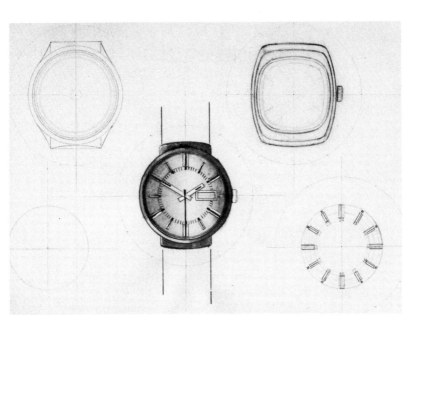

Boiling Wand

Personal electric water heater

This bizarre item was a must-have for every Soviet traveler. For the price of a ruble and some change (not quite a trifling amount), the prudent tourist would never have to worry about eating their canned cod sandwiches without hot tea.

It was almost forty years after the first electric tea kettle was manufactured by the German appliance company AEG that another German, Dr. Theodor Stiebel, invented a plug-in cylindrical wand in 1924. Until the late 1920s, appliances such as Stiebel's were imported into the USSR, after which they came to be produced domestically, to a great decline in quality. At 220 volts, the water heaters were infamous for shorting out fuses. Stories abound of Soviet tourists abroad shutting down entire city blocks with their magic wands wherever they carried them.

Especially popular among soldiers, prisoners, and students, the homemade version consists of a cut-off electrical cord, two razors, and two matchsticks. The cord is stripped at its end and the wires are divided into two bundles. Each bundle is attached to a razor and then yoked together a centimeter or so apart by four broken matchstick ends, placed along the hollow portion of the razors. You may then plug in the apparatus and boil some water. Often, without even getting electrocuted.

Through the advent of automatic electric kettles and an improved economy, portable electric water heaters are no longer common. These days, electric heat on a stick is relegated to the novelty bin (there's a version of the device powered through a USB cable). Like many thankfully obsolete gadgets, what they've lost in necessity and danger, the new generation makes up for in pretension and silliness.

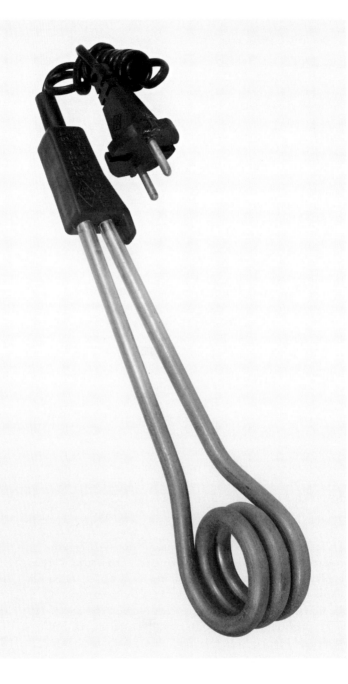

Krugozor

Multimedia magazine

Some bohemian Russian types like to gloss nostalgic about
the Soviet age, when money was not an issue, artists were
free to "create," and no one had to play degrading and
soul-crushing games in order to finance their projects.
Most of the time, this is pure fantasy—the state was a far
worse censor than the market. But sometimes, seeing is
believing. So picture this: a monthly news and music
magazine consisting of sixteen "pages," which are actually
the covers for six flexible (and sometimes colored) vinyl
records with stories, interviews, and songs, all interspersed
with bright and often psychedelic illustrations and
photographs. This isn't the description of a young zinester's
wet dream. This is *Krugozor*, an actual Soviet magazine
that existed for nearly thirty years, from 1964 to 1993, and
had a circulation of up to five hundred thousand.

Krugozor, lovingly referred to by its creators as "the little
magazine with a hole," was recognized as an object d'art and
a collector's item by all who had it and all who coveted it.
Those lucky enough to be subscribers (or to nab one off
the newsstands) treasured their back issues. *Krugozor*
had something for everybody. Its audio offerings ranged
from field reports from exotic locales to forbidden pop
music from around the world. Issue after issue hid gem after
gem: a recording made in outer space with songs written
by cosmonauts, an interview with Dmitry Shostakovich,

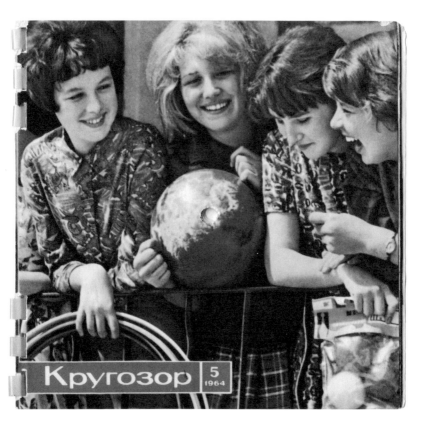

Кругозор 5
1964

НАШ ДРУГ АНДЖЕЛА

②

Анджела ДЭВИС:
«Ничто не может помешать мне
продолжать борьбу
за свободу моего народа».
Рассказ об Анджеле Дэвис
слушайте на второй
звуковой странице.

a "fono-film of a Spanish corrida," obscure folk music from Yemen. With the very first issue of the magazine, the editors introduced a new genre of creative reporting: the "song story," which was both a journalistic piece and a musical composition on a given subject (space travel and labor were favorites). These things were essentially, for the lack of a better word, podcasts.

КОММУНИСТ—ЭТО БОЕЦ

В Москве стояли трескучие морозы, каких, по словам синоптиков, не было сто лет. А ее тянуло на улицы «посмотреть русскую зиму».

И вот идем по Кутузовскому проспекту. На Анджеле черное пальто и рыжая лисья шляпа, которая едва держится на пышных густых волосах. Под ногами поскрипывает снег. Мы ее поторапливаем, а она остановилась:

— Удивительно! Такой мороз, а все работает: транспорт, электричество, магазины... И, смотрите, сколько людей на улицах!.. В такой мороз жизнь должна бы замереть. Так и бывает в Нью-Йорке или Чикаго, когда там случаются холода.

Помолчав, говорит глубоким взволнованным голосом:

— Теперь я еще лучше понимаю, как трудно было вам в военную зиму...—И вдруг живо оборачивается вслед прохожему:— А это что? Что за бутсы?

— Эти бутсы — русские валенки, Анджела.

— А почему мужчины не завязывают тесемки шапок?

— Наверное, им жарко...

Жарко. И вспомнился тот августовский день, когда синоптики говорили: «Такого не было сто лет». В то знойное лето Анджела впервые прилетела в Советский Союз, сразу после ее освобождения из тюрьмы. Она провела у нас две недели и удивляла всех своей неутомимостью, неуемной жаждой узнать и увидеть как можно больше. Она не расставалась с толстым блокнотом, в который записывала все мелким, убористым почерком.

Прошло шесть лет. Анджела по-прежнему очень искренна, открытая, скромная, так же жадно впитывает в себя все увиденное. И все-таки, думаю, есть в ней нечто новое. Если бы Анджела не была так молода, я сказала бы, что она стала более умудренной жизненным опытом. Впрочем, коммунисты-революционеры мужают и приобретают опыт с юных лет.

Как-то раз Анджела сказала: «Меня учила сама жизнь в США, особенно на расистском Юге. Когда видишь, как у тебя на глазах убивают твоих друзей только за то, что они черные, когда с раннего детства сам себя чувствуешь на каждом шагу оскорбленным и униженным, когда цвет твоей кожи делает тебя человеком «низшего сорта», рано или поздно начинаешь задумываться над этим. И когда на этом фоне ты познаешь марксизм-ленинизм, то неизбежно приходишь к пониманию, что единственно правильный путь к полному равенству и свободе — это политическая и социальная борьба, это социализм и коммунизм».

Популярность Анджелы в нашей стране необычайна. Это, впрочем, неудивительно: ведь все советские люди так или иначе участвовали в борьбе за ее освобождение из тюремных застенков. Каждая встреча с Анджелой была волнующим событием. С чувством глубокой признательности вспоминает она рабочих Кировского завода в Ленинграде: «Я всегда помню о той высокой чести, которую они оказали мне, избрав почетным членом их коллектива. Помню и никогда не уроню ее».

В Узбекистане, глядя на бескрайние хлопковые поля, возделанные на бывших безжизненных залежах Голодной степи, Анджела сказала: «Вот здесь, на этих полях, мы видим, какой гигантской революционной силой обладает социализм».

В тихом, уютном Доме-музее Л. Н. Толстого, что в бывшем Долгохамовническом переулке, Анджела узнала, что однажды великий русский писатель получил письмо от двух американских журналисток-негритянок, в котором они просили Толстого поднять голос протеста против расизма и линчевания в США. Толстой ответил на этот призыв. Взволнованная Анджела записывает имена своих соотечественниц, Штат Индиана... Она поедет туда, попытается отыскать следы этих женщин. Это очень важно для ее новой книги «Расизм и женский вопрос».

Особенно хотелось бы сказать о том, как легко и свободно, с первой встречи, чувствует себя Анджела среди советских людей. Поистине, как в родной семье. И когда мне довелось однажды говорить с ее матерью, я поняла, что это чувство доверия и любви к советским людям свойственно всем членам семьи Дэвис.

В нашей стране тоже особое отношение к Анджеле. Ее не раз спрашивали, как спрашивают близкого человека: «Анджела, как ты живешь? Есть ли у тебя работа? Опасно там?»

И, как своим близким, Анджела рассказывает, что с помощью друзей она оправилась после тюремного заключения, хотя и следовало бы еще отдохнуть... С работой тоже нелегко. Сейчас она преподает по договору в университете Лос-Анджелеса, но твердой гарантии нет. За право работать все еще приходится бороться. Много времени отдает политической деятельности. Опасно? Конечно, в Соединенных Штатах ни один борец против расовой и социальной несправедливости не находится вне опасности. Как-то раз на митинг, где она выступала, прорвалась группа расистских молодчиков. Бросили гранату, стреляли. К счастью, все обошлось благополучно.

...Когда мы прощались с Анджелой Дэвис на аэродроме, мы от всей души желали ей и всем американским коммунистам успехов в их мужественной борьбе.

Ольга ЧЕЧЕТКИНА,
заместитель председателя Комитета советских женщин

To the Readers of *Krugozor*-
Best wishes!
Yours in the struggle for
Peace, Liberation and Socialism,

Angela Y. Davis

Like many good things, *Krugozor* appeared as the result of one of Nikita Khruschev's trips to the West. Somewhere on his route through the capitalist territories, the observant Khruschev laid eyes on a magazine that came with a record. "Do we have one of these?" "No." "We will," he declared, not suspecting that the Soviet Union would respond by producing something completely unique. In 1964, Soviet authorities procured from France a machine that pressed thin, floppy vinyl disks, and charged a group of people working at All-Soviet Radio with the task of forming an editorial board. The board decided on the format, which would include audio, text, and photography to provide readers and listeners with a full sensory experience. The magazine was named by the writer Lev Kassil; "*krugozor*" is a beautifully subtle pun, a word for "outlook" that incorporates the word for "circle" or "round" ("*krug*"). It was the round tear-out disks in *Krugozor* that gave Russians their first nonbootleg recordings of everyone from Barbra Streisand to Pink Floyd to Michael Jackson.

And of course, all good things must come to an end, especially if they are funded by an oppressive and crumbling regime. *Krugozor* received its last bit of financing in 1991, and spent it on an epically misguided idea to include cassette recordings with every issue. In the end, nothing could save this magical and very expensive institution. Almost twenty years into its afterlife, *Krugozor* is now being scanned and digitized, slowly and painstakingly, from issues saved by collectors.

Vesna 309–4

Portable cassette recorder

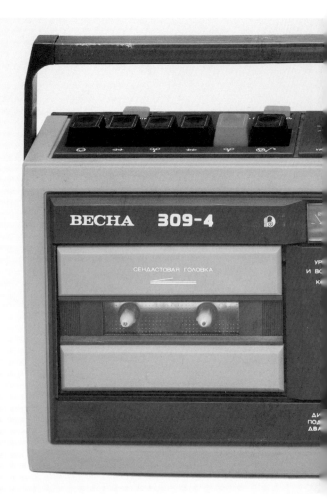

Before anyone anywhere was worrying about music piracy, the Soviets were preserving their counterculture one homemade recording at a time. The sister of samizdat book publishing was magnitizdat: self-publishing on tape. The mass-production of reel-to-reel tape decks coincided

with the underground artistic flowering that began in
the 1960s. The new generation of poets unafraid to sing
about forbidden things—poverty, oppression, censorship—
blossomed to the patient rolling of tapes recording their
every word. Countercultural art began in the big cities,
but it thrived throughout the provinces as these recordings
were passed from hand to hand. Authorities officially
criminalized samizdat, but largely left magnitizdat alone.
What you couldn't commit to paper, you could wind onto
a reel.

By the 1980s, Soviet culture had changed drastically. Two
generations removed from Stalin's purges, even the most
flagrant individualists were a little less scared of getting
killed. With the introduction of cassettes and the palpable
dearth of vinyl, homemade recording became less a matter
of artistic necessity and more of a way to distribute already
popular music. At the same time, underground bands
began independently releasing genuine (anti-)Soviet rock
and roll straight onto cassette. The sacred dream of the
Soviet teenager in the 1980s became the double tape deck.
In a short, stagnant twenty-year stretch, priorities had
shifted from poetry to Panasonic.

A foreign-made stereo was an obsessive and unobtainable
dream. The craze gave rise to legends: People believed that if
you opened up the back of a Japanese tape deck, it would
burst into flames, destroying any chances you had of learning
how to reproduce it. While the hundreds of domestic models
didn't quite burst into flames at will, they did exhibit a
particular appetite for tape, chewing it as often as they
could. Vesnas were among the first to appear, followed by
Ritms, Sonatas, Latvian-made Radiotehnikas (which were
considered the best), and scores more. They chased after
the Japanese as best they could, with an occasional burst
of homegrown ingenuity and mod color, like the orange and
burgundy Vesna 309-4. None could quite stack up to their
foreign counterparts in sound quality, but, like so many
things made in the USSR, they were unbreakable. The final
advantage was this: if your Soviet stereo was being reluctant,
hitting it always worked.

Disco Light Set

Home entertainment system

The Soviets loved their disco—a love that was not entirely discouraged by the government. Next to domestic rock and roll, which was surly, cerebral, poetic, and politically dangerous, disco was a palatable alternative. Instead of fighting it, the system showed unexpected smarts by co-opting it. This meant official *diskotekas* (often held in movie theaters on off nights), a few disco LPs pressed on government vinyl, and, most amazingly, plenty of disco lights.

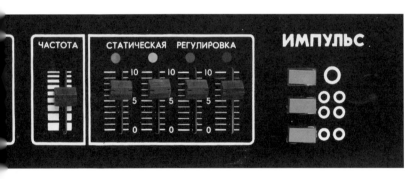

Starting slowly at the end of the 1970s and building into a downright deluge toward the early 1990s, mass-produced disco lights of every stripe and color began pouring out of Soviet factories. They ranged from compact home sets to bulky club units. Moscow's Temp radio factory made a souvenir disco light shaped like a television, with a semi-transparent screen with the Kremlin on it; a home appliances factory in Ulyanovsk came out with Prometheus 1 ("Prometheus" was a popular name for the devices, what with the fire bringing and all); Illusions, Spectres, and Rostov-Dons were made by the thousands from Leningrad to Krasnoyarsk. Technical magazines ran articles on how to construct your own. Brochures such as *Light Organs? How Interesting!*, published in Kiev in 1985 and intended for teenage readers, proliferated. That this bounty of expensive novelty items flooded a semi-starving country, whose food markets carried three kinds of cheese on a good day, was baffling.

An easy explanation would be that the system had simply run with the one aspect of disco culture it could understand: It took a hedonistic experience and turned it into an engineering project. Then again, perhaps history played a role. Russia's first display of dancing electric light was introduced by the composer Alexander Scriabin in his 1910 symphonic piece, *Prometheus: The Poem of Fire* (see?). For this piece, Scriabin invented the clavier *à lumières*, a kind of a light-equipped organ for which he wrote the score in colors. He had wanted the audience to be dressed in all white so that the projected colors would reflect off them and flood the room. Sadly, the instrument hardly ever appeared in performances of the piece. It would have to wait until the late 1970s for its shining hour.

ISSN 0130-2698

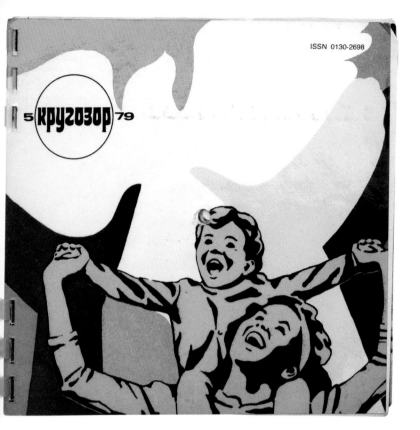

5 **кругозор** 79

ВАРВАРА СТРЕЙЗАНД

⑫

Цена 1 руб.

ЭСТРАДА ПЛАНЕТЫ

«Смешная девчонка» Барбара Джоан Стрейзанд родилась в апреле 1942 года в Бруклине, одном из пяти округов Нью-Йорка. Очень рано потеряв отца, она росла в условиях, которые даже по бруклинским понятиям следует назвать убогими. «Времена были тяжелые, серый волк голода был у дверей, и большую часть детства я просто стерла с доски моей памяти, — вспоминала она позже много позже, когда Барбары уже не существовало, потому что обладательница этого имени решительно выбросила из него одно «а», надеясь на благосклонность капризной славы и скорую встречу с ней.

Сцена манила Барбру с непреодолимой силой, и она не преувеличивает, когда говорит: «Я не заработала ни одного доллара, который не имел бы отношения к сцене». Уйдя в четырнадцать лет из дома, она начала свою сценическую карьеру билетершей в одном из бродвейских театров, а подрабатывала еще тем, что подметала полы в другом театре. Ночевала в конторах театральных агентов, которым было жаль девушку, таскавшую с места на место раскладушку и копившую деньги — цент к центу на уроки актерского мастерства.

Одержимость и фантастическая работоспособность дали свои первые плоды в 1961 году, когда блестящий талант Барбры одержал победу в любительском конкурсе артистов. Она получила приглашение выступить в одном из лучших кабаре Гринич-Вилладж. Там Барбра незабвенную детскую песню «Нам не страшен серый волк». Как писали критики, в ее исполнении «сказочные персонажи ожили, стали реальными, и порой меренилось, что вся сцена превращается в огромную пасть кровожадного зверя».

Три с половиной года спустя Стрейзанд дебютировала в главной роли мюзикла «Смешная девчонка», известного теперь и советским зрителям, так что не стоит говорить о драматическом мастерстве артистки, ее щедром вокальном даровании. Стрейзанд пахнента. Ну всякий всё помнит, что серый волк все-таки страшен. Ведь она смотрела ему в глаза...

В. ПОЗНЕР

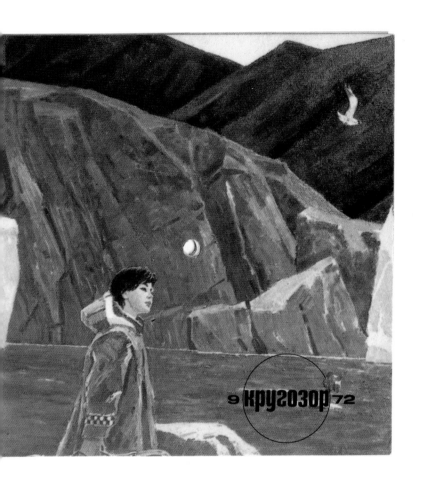

9 кругозор 72

ISSN 0130-2698

ДИАЛОГ О ВДОХ...

К-

с...
лю...
под...
етет...
стски т...
ской т...
БАТА...
выпали го...
Мне очен...
равли». Его н...
был старше м...
ни и подвиге к...
было для меня нра...
Если бы Борис ве...
кантом, поэтом, а мо...

Пристрастия скрипки

Рассказывает Виктор ТРЕТЬЯКОВ

...ОТВЕТСТВЕННОСТЬ... чувство ответственности, настоящей, столь же почетной, сколь и трудной. Я испытал это, став победителем состязания скрипачей на Международном конкурсе имени Чайковского. Хочу пояснить передуманное с тех пор неоднократно. Как-то незаметно, но прочно канула в вечность эпоха вундеркиндов. Может быть, два последних слова звучат, а ведь действительно это была эпоха.

Было время, когда на эстраде под шумные аплодисменты царили юные дарования в коротких штанишках, беспечные, как соловушки. Их больше нет, почти нет. И вместе с тем мы должны констатировать, что место настоящего музыканта-исполнителя в большой музыке теперь определяется, когда ему где-то около двадцати. Так было с моими коллегами. Олег Каган — интеллектуал, музыкант, которому удаются столь разные стили. Затем «неистовый романтик» Владимир Ланцман. И еще мне хочется назвать блестящую, остроумную Лиану Исаакадзе рядом с виртуозной Ириной Бочковой.

Естественно, я назвал скрипачей, да и лишь тех, кого лучше знаю. А уж если говорить о поколении вообще, то, пожалуй, чувство ответственности присуще ему больше всего. Публика без энтузиазма теперь воспринимает чистую виртуозность. Время диктует гражданственность искусства. Сцена — трибуна, зал — митинг, музыка — речь, обращенная к людям. В двадцать лет мы должны не только хорошо играть. Мы должны знать и решить для себя абсолютно точно, что мы хотим сказать играя. Мое поколение — публицисты в музыке. И именно осознание этого обстоятельства делает музыкантов моего поколения серьезными, ищущими.

...ОЗАБОЧЕННОСТЬ... может быть, то, что я уже сказал, не очень ясно, я многое для себя сделал до конца не уяснил. Но продолжаю стоять на том, что музыкант теперь в двадцать лет или уже готовый артист, или же надо менять профессию, пока не поздно. И вот конкурсы... Их стало невероятно много. Они, безусловно, полезны. Позволяют как-то сравнить национальные школы, сближают молодежь. Но создалось положение, при котором международное лауреатство стало едва ли не единственным путем и возможностью концертировать. Мне не представляется единственным правильным этакий принцип — принцип «естественного спортивного отбора». Думаю, рано или поздно возникнут такие же просто музыкальные фестивали молодежи, где будет царить атмосфера праздника искусства, а не состязания только. И там наши прославленные, маститые без конкурсной суеты, без подсчета очков и фальшивых нот смогут решить, «кто есть кто» в мире молодой музыки, кто ее будущее.

Виктор Третьяков, студент Московской консерватории. Победитель конкурса имени Чайковского. Лауреат премии Ленинского комсомола.

Монолог записал
Анатолий Агамиров

9

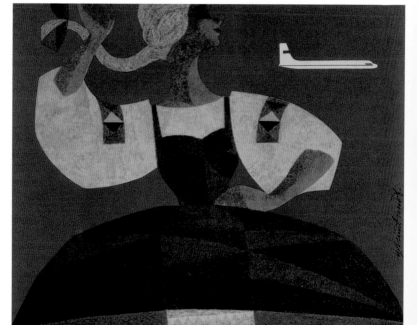

АЭРОФЛОТ 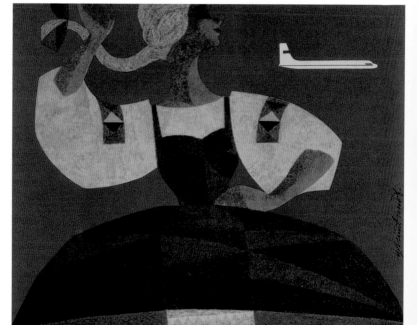 *Soviet airlines*

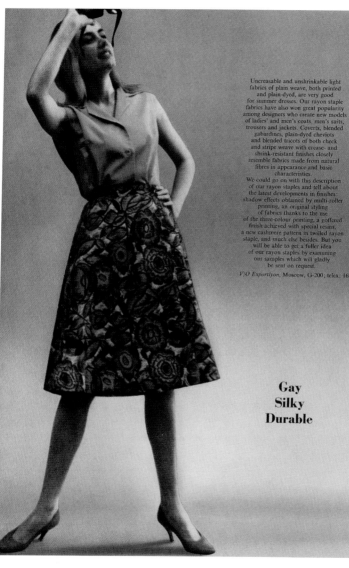

Uncreasable and unshrinkable light
fabrics of plain weave, both printed
and plain-dyed, are very good
for summer dresses. Our rayon staple
fabrics have also won great popularity
among designers who create new models
of ladies' and men's coats, men's suits,
trousers and jackets. Coverts, blended
gabardines, plain-dyed cheviots
and blended tricots of both check
and stripe weave with crease- and
shrink-resistant finishes closely
resemble fabrics made from natural
fibres in appearance and basic
characteristics.
We could go on with this description
of our rayon staples and tell about
the latest developments in finishes:
shadow effects obtained by multi-roller
printing, an original styling
of fabrics thanks to the use
of the three-colour printing, a goffered
finish achieved with special resins,
a new cashmere pattern in twilled rayon
staple, and much else besides. But you
will be able to get a fuller idea
of our rayon staples by examining
our samples which will gladly
be sent on request.

V/O Exportlyon, Moscow, G-200; telex: 168.

**Gay
Silky
Durable**

Для владельцев «ЗАПОРОЖЦА» не существует трудностей передвижения в современном городе. Даже в часы пик он проскользнет везде и всегда найдет стоянку. Тщательно продуманный комфорт, просторный багажник, исключительная прочность — достоинства, делающие «ЗАПОРОЖЕЦ» удобным в туристских поездках.

- Количество мест — 4 ● Максимальная скорость — 120 км/ч
- Расход топлива — 5,5 л/100 км ● Мощность двигателя — 45 л.с.
- Радиус поворота — 5,5 м

«Запорожец» ЗАЗ-966 — автомобиль для всех и каждого

Экспортер:
В/О АВТОЭКСПОРТ,
Москва, Г-200. Телекс: 135.

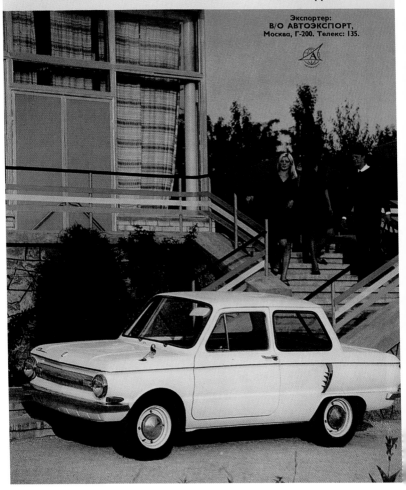

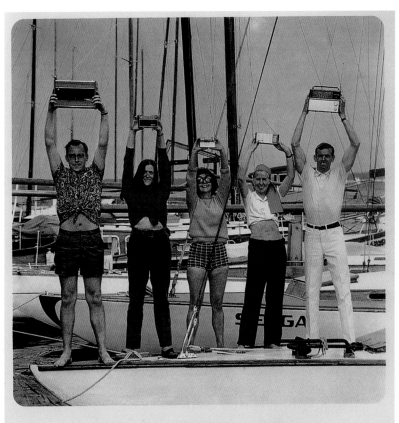

SUS CLIENTES TAMBIEN
QUEDARAN SATISFECHOS CON
LOS RECEPTORES DE RADIO SOVIETICOS

De un pequeñísimo receptor a transistores de dos ondas hasta el receptor de todas
ondas de muchos diapasones ofrece V/O MASHPRIBORINTORG, Moscú, G-200.
Télexes: 235, 236.

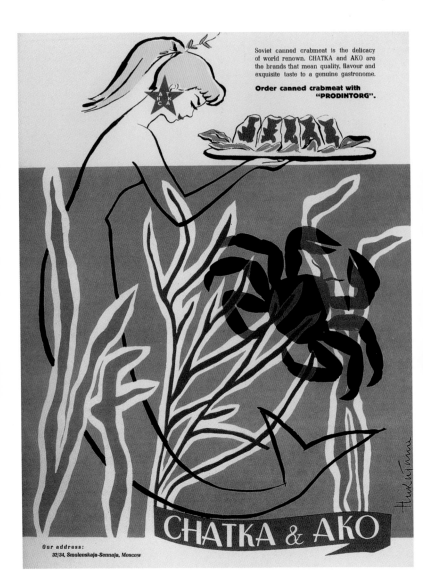

Soviet canned crabmeat is the delicacy of world renown. CHATKA and AKO are the brands that mean quality, flavour and exquisite taste to a genuine gastronome.

Order canned crabmeat with "PRODINTORG".

CHATKA & AKO

Our address:
32/34, Smolenskaja-Sennaja, Moscow

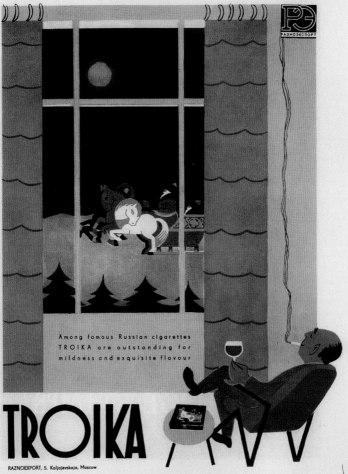

Among famous Russian cigarettes
TROIKA are outstanding for
mildness and exquisite flavour

TROIKA

RAZNOEXPORT, 5, Kaljajevskaja, Moscow

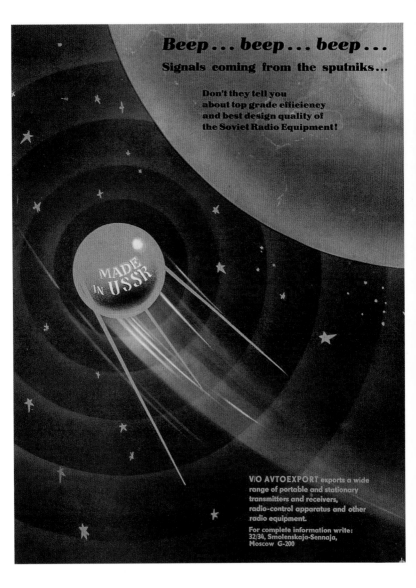

Beep... beep... beep...

Signals coming from the sputniks...

Don't they tell you
about top grade efficiency
and best design quality of
the Soviet Radio Equipment!

MADE IN USSR

V/O AVTOEXPORT exports a wide
range of portable and stationary
transmitters and receivers,
radio-control apparatus and other
radio equipment.

For complete information write:
32/34, Smolenskaja-Sennaja,
Moscow G-200

Speedy,
Attractive,
Economical,

V/O Avtoexport exports first-class comfortable VP-150 and T-200 scooters of 150 and 200 cu. cm. piston displacements. Excellent design and workman-ship ensure long service and durability.

For information write to
V/O AVTOEXPORT,
Moscow, G-200.

Scooters

Handheld video game

Does this game look familiar? That is because it, and others like it, are almost exact replicas of Nintendo's Game & Watch consoles, manufactured two years before these appeared in the Soviet Union. The year was 1984, and the only thing more maddening than the noise the Elektronika games made (a kind of persistent timebomb "tick-tick-beep") was their sudden ubiquity: Ten factories throughout the Soviet Union started putting them out at the same time.

The general premise of these games was that something was falling from somewhere, and the player had to catch it. In the Japanese game Egg that starred Mickey Mouse, the falling objects were eggs. In cloning these amusements, the stroke of genius was finding the local equivalent to Mickey. The Soviet version of Egg was called Just You Wait! (Nu, Pogodi!) after the wildly popular cartoon, which featured the adventures of a no-good wolf and a clever bunny. Identified with the wolf, the player was to catch eggs rolling out of henhouses. Though the Soviets may have been inspired by the fact that the original Egg had also featured a wolf, this was *their* wolf; In fact, Nu, Pogodi! was the country's first film-to-computer game merchandizing coup.

Less than a year later, Soviet engineers figured out how to fully reproduce the microchips used in these devices. From 1985 until the early 1990s, countless variations on the original handheld games appeared: valiant attempts at chess simulation; Orpheus the synthesizer; and an experimental series of handheld 3-D games played through stereoscopic binoculars. However, just one year after the craze began in earnest, the Elektronikas suddenly had something much bigger to contend with. In 1985, the Soviets came out with Tetris. As they say in Japan: "Game Over."

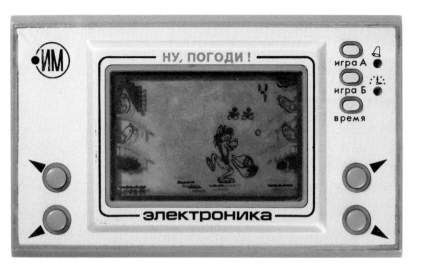

Double-dial competition chess clock

It's no surprise that the man urging the Olympic Committee to recognize chess as an Olympic sport is a Russian. After all, chess has long been considered Russia's national game—whether it's actually classified as a sport or not. The IOC may be reluctant to count the exhaustion and weight loss common in serious chess tournaments as evidence of its being a vigorous physical competition. They are gravely, but politely, pointed to the chess clock: The standing reminder that the game isn't just about thinking, it's about thinking fast. Or, at least, fast for chess.

The double-dial clock was first used in a chess tournament in London in 1883. It was a sorely needed development: During an 1851 tournament, one game was considered a draw due to the fact that both players had fallen asleep before either had won. The next modification belongs to the Dutch, who added the sadistic little red flag that falls when a player's time is up. But the classic form of the mechanical chess clock was perfected, like the game itself, by the Soviets.

The renowned Yantar ("amber") factory in Orel was the country's first and only name in chess clocks, and the original remarkable design must belong to one of its many nameless engineers. Crafted from white metal, with a ribbed Art Deco pattern on the sides and two slappable black buttons with just the right amount of give, the Yantar clock watched with stubborn pride as many of the century's greatest chess players battled to checkmate. A snazzy gold-or silver-colored rectangle surrounds the double faces. The modern iteration of the clock looks a little cheaper, stamped as it is from plastic and made in Azerbaijan, but the face—and the name—remain unchanged.

BK-0010

Personal computer

In 1985, to the joy of all those who didn't yet know what a joystick was, the first personal computer appeared in the Soviet Union. The Elektronika BK (the letters stand for "home computer") was developed by the NPO Scientific Center, which was then on the forefront of microcomputer design in the USSR. The "*bukashka*" ("bug"), as it was lovingly nicknamed, bore only a passing resemblance to what we would call a PC today. It was basically a keyboard. In order to be used, it needed to be plugged into a television and, if you wanted to store anything, a stereo—and a Soviet-made one at that. The resulting device boasted 32kb of memory; a 3MHz CPU (not too bad for its time); some examples of programming for BASIC and its already hoary predecessor, FOCAL; and a few test games. As for the keyboard itself, it was the membrane kind: to type, you pressed on plastic bubbles normally hidden by key caps. While this made it more dust and spillproof, it was remarkably unpleasant to use, and a year later BKs started coming out with standard keyboards.

Essentially, the computer was a tabula rasa. And, after the first wave of disappointment, it quickly became clear that this was actually every tinkerer's dream come true. As amateur developers concocted everything from simple algorithm games to whole operating systems and homemade disk drives, BK clubs flourished across cities and on the pages of magazines such as *Information Technology* and *Education*. Around the same time the machines, or rather specialized models called Elektronika BK-0010Sh (with the "sh" for "*shkola*") had started appearing in schools. On these computers, children could learn basic programming and gain familiarity with word processing and database systems. There was even software that served as supplemental material to their regular courses of study. In short, the BK is the reason your company's IT support team is fifty percent Russian. Yet its bare-bones severity also laid the foundation for the emergence of the mighty Russian hacker. It taught a whole generation that even with minimal hardware, all you needed was ingenuity, a soldering iron, and maybe a few friends to transform a primitive slab of plastic into a powerful machine.

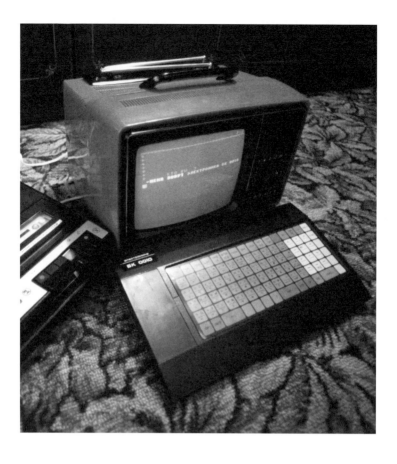

Tonika, Formanta, Ural

Electric six-string and bass guitars

"If today it's jazz he plays/Tomorrow Russia he betrays!"
was a common slogan around Soviet musical conservatories
in the 1930s. (It's not much better in the original.) About
thirty years later, the authorities had a similar reaction to
rock and roll. The first official report on the Beatles
appeared in a 1965 issue of the satirical magazine *Krokodil*
(*Crocodile*). It depicted the Fab Four as bourgeois madmen
making a racket that had nothing to do with "true music."
Krokodil, of course, did nothing to stop this racket from
making the rounds on low-quality tape dubs of BBC and
Radio Liberty broadcasts. As the regime had correctly feared,
all who heard the Beatles were instantly transformed into
enemies of the state. And the enemies wanted to rock.

Yuri Mukhin, the first electric guitar player in the Soviet
Union, recalls dismantling a pay phone in order to steal the
necessary parts to build his first guitar with engineer friends
in the late 1940s. By the early 1960s, a very limited number
of foreign-made guitars from the Eastern Bloc had made it
into Soviet hands—most notably, the East German Musima.
However, it was not until the late 1960s that the first
domestic axes hit the market.

St. Petersburg's Lunacharsky factory, the oldest string
instrument maker in the USSR, came out with the Tonika
around 1967. It was a terrible instrument, though it looked
pretty cool. Unusual at first glance, its shape was actually

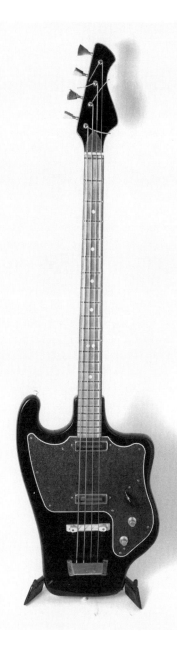

common to many early electric guitars and appears to be inspired by the Fender Jaguar. Some attribute the shape to abandoned plans to place a speaker on the head, while others explain its prominent lower lip as a vestigial adaptation in order to make the guitar comfortable to play while sitting down. Because of the way the instrument was weighted, balancing it on one knee turned out to be impossible. In general, the Tonika, like the electric guitars that would follow it, was virtually unplayable.

The Ural guitars and basses appeared out of Sverdlosk, starting around 1975, and became the most popular electric guitars in the country. The Ural was another typical example of Soviet manufacturing—an instrument produced for durability with little concern for functionality. It may have been incredibly heavy and had a ridiculous neck that was both small and hard to grip, but it was also virtually impossible to break. If a particularly rebellious Soviet rocker wanted to smash the instrument onstage, he would have had a very hard time doing so. As for the Ural bass, it was said to sound like Paul McCartney circa 1964 through a two-inch radio speaker.

Later instruments, such as the Formanta and the Belorussian-made Solo 2, produced in the 1980s, showed little improvement. The guitars looked strangely beautiful, and came in metallic colors—even pink. However, each went out of tune almost as soon as it was touched. The Solo, at least, was lighter than the Ural, though not by much. Serious enemies of the state would either have to find ways to get foreign guitars or custom build their own, both of which were common practice. Even in the footage of state-approved electric guitar bands from the 1970s, or VIAs ("vocal-instrumental ensembles"), it is very rare to see an actual Soviet guitar. Most are playing Musimas, the luckiest few, Yamahas. But the fact remains that no Western, or Far Eastern, guitar could beat the Ural on price. Even today, thousands of Russian musicians on a budget continue to struggle with these affectionately nicknamed "logs" ("*drova*") of rock.

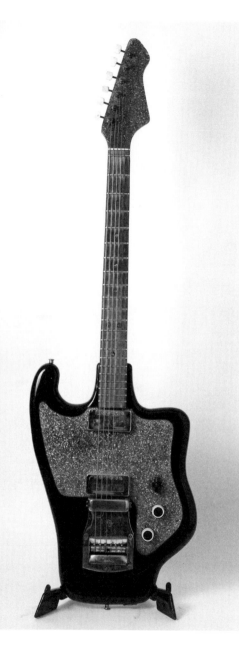

Girls' School Uniform

Iconically infamous design

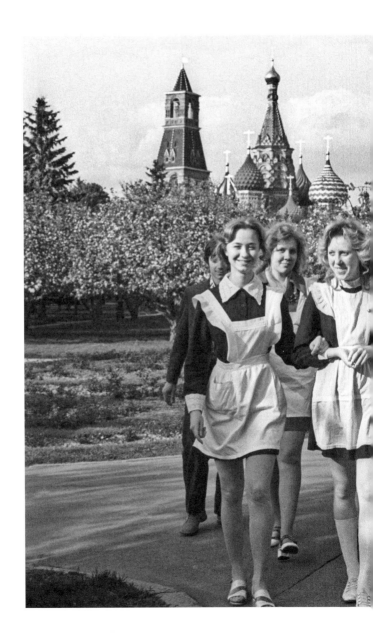

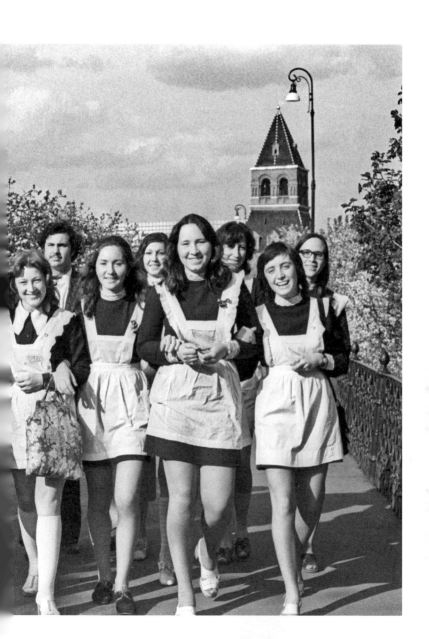

The problem with my school uniform was that it never had a chance to fit. The uniform consisted of the dark brown dress with white collar and cuffs and the black pinafore (white for important holidays like Revolution Day). The brilliance of the design allowed you to create the illusion of an hourglass figure no matter how unhourglass your figure really was. The only condition for this design to work was that the uniform be the right size. No such luck for me.

My mother wanted the uniform to last longer, so she would buy it a size too large. The first few days after the purchase, when I looked at myself in the mirror, I saw something resembling a clothes hanger draped with loose folds of dark material and no suggestion of feminine form. I had no choice other than to wait for my body to expand and fill the uniform better. I would wear it every day, constantly checking on the progress.

Meanwhile, there were two more obstacles: my cuffs-and-collar set and my woolen trousers. The white cuffs and collar needed to remain white. They had to be washed every week. To do that I had to unmoor them from the rest of the uniform, wash them, dry them, iron them, and then sew them back on. I had never been good with needles, or with irons for that matter. The whole process was so much torture that I kept cursing my collar and cuffs while working with them. They paid me back by being stubborn and sneaky. When I finished sewing, I would always find that the collar was either askew or bunched up around my neck, and the cuffs were of a slightly different width. But none of that bothered me as much as my woolen trousers.

In the harsh winter months most girls wore woolen tights under their uniforms. The reason was, of course, that if you didn't, you would catch cold in your reproductive organs and wouldn't be able to have children. (When I came to the US, I was amazed to

see Catholic schoolgirls wear their uniform miniskirts over naked thighs in winter. But then, who knows, maybe Russians have weaker reproductive organs than Americans.) My problem was that in the first and second grades, I had to wear woolen trousers instead of tights. I don't remember why. Could be that the tights were hard to find in the stores, or that my mother believed that trousers would give my reproductive organs better protection. I do remember that my trousers were blue and very thick. I also remember that Moscow winters were long, and even longer in my mother's opinion, so I had to wear the trousers for very long stretches of time. I would take them off as soon as I walked into school. I could go to the bathroom and remove them there, but the bathroom was on the third floor, and I couldn't let anybody see me in these trousers as I walked there. So I learned how to take them off without lifting my skirt. I had to pinch them through the material of the skirt and pull them down. After a while, I became quite proficient. I wonder if I could still do it.

My struggle with cuffs and trousers distracted me from monitoring the expansion of my form, and when the uniform actually began to fit, it took me by surprise. One morning I looked in the mirror and gaped at my reflection. There it was: a well-defined waistline, a nice swell of pinafore on my chest, ruffled straps on my shoulders. I didn't look like a woman yet, but like an idea of a woman I would become one day. None of my other clothes made me look like that.

But then, of course, my mother appeared out of nowhere and commented on how threadbare and greasy my uniform had become, and how we needed to buy a new one soon.

Lara Vapnyar

Mark of Quality

Official stamp of governmental approval

In 1967, the Soviet government introduced the Mark of Quality. The authorities believed that the mark, granted upon a product's examination by committee, would stimulate manufacturers to produce better wares and consumers to buy them. Upon receiving it, the price of an item was raised by ten percent; this was the stimulus. The system was installed not out of a need to guarantee better products, but to stimulate sales. In fact, it was a shrewd capital-driven adaptation of an old practice: the Russian Imperial Seal. In Tsarist times, vendors supplied the palace with their wares, free of charge, for years—sometimes, decades—before they would receive the Imperial Seal. Tsars would approve only a handful of merchants during their reign, and thus the seal had great prestige.

The mark itself was a pentagram, like the Soviet star. Some documents surrounding it explained that the mark's five points symbolized the five signs of quality: affordability, durability, safety, beauty, and innovation. People also believed that the stylized arrangement of triangles represented the letter *K* turned on its side—the first letter in the Russian word for "quality." Once the mark began appearing on typically underwhelming examples of Soviet production during the 1980s, people joked that it was a pictogram of a man shrugging—as if to say, "This was the best I could do."

The Mark of Quality steadily devalued as the authorities desperately clambered to use it to plug up the holes in their sinking ship. Today, however, there are still a number of items around bearing this mark of the bygone beast, and some are in perfect working order. Soviet-made irons seem to be particularly durable. In post-Soviet Russia, the government has attempted to resurrect this institution a number of times, but to no avail. Where the approval of Tsars can be bought and sold, the common folk can afford to ignore it.

Zaporozhets

Soviet subcompact car

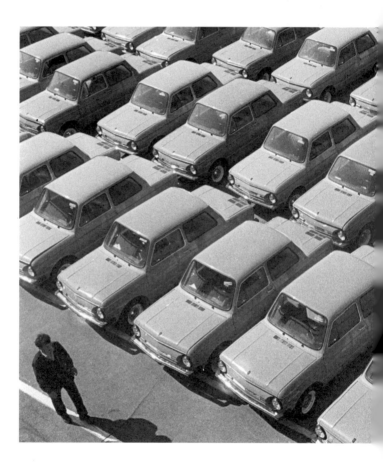

The Zaporozhets was the Soviet answer to the compact
vehicles that proliferated in 1950s Europe. While cars
such as the Volkswagon Beetle were buzzing down the newly
repaved autobahn, the Soviet auto industry was chugging
out a meager hundred thousand lightweight cars a
year. Luckily, in 1955, the Italians built the Fiat 600, a small,
funny-looking machine that was ripe for a knockoff.

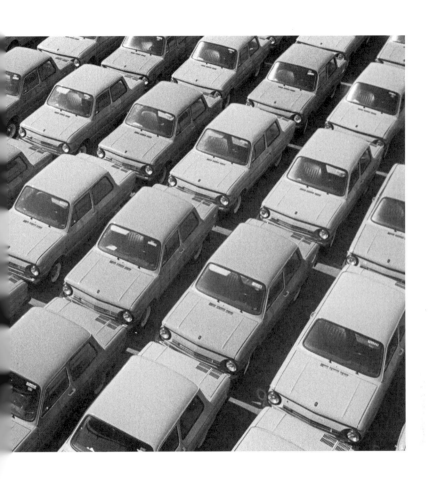

Three years later the Zaporozhets—later to be known simply as Zapor, "the constipated"—was born.

Before it could meet the people, the Zaporozhets had to be tested personally by Nikita Khruschev. The secretary general had ordered the construction of the car soon after being embarrassed by a French coupe that was too small to fit him, and needed to be sure the Soviets hadn't made the same mistake. After it proved to be Khruschev-sized, the secretary general was so glad, he slashed the price by two hundred rubles. (Not that the price needed slashing. According to one of the many legends surrounding this car, the head engineer, Vladimir Steshenko, developed it with the idea that it shouldn't cost more than a thousand bottles of vodka.)

At about half the cost of other Soviet-made vehicles, the Zaporozhets was cheap, furious, and full of idiosyncrasies. The part-aluminum engine was in the back. Weirdly earlike air intakes were put on the sides of the car to cool it. It could hardly go more than eighty miles per hour and broke down frequently, sometimes explosively. One of the models had a removable floor panel right under the driver's feet—for ice fishing. Another had hand-operated pedals and was given for free to the handicapped. New tweaks in the design appeared over the years, but the car's essential problems were never rethought. Instead, they became the stuff of legend (and of a myriad of untranslatable jokes). In the USSR in the 1960s, the mere fact of car ownership was a massive status symbol—unless the car was a Zaporozhets.

Nevertheless, the price point always won. Simply constructed, the Zaporozhets was easy to take apart and even easier to soup up. Countless drivers found their first car in the Zaporozhets, and a generation of mechanics grew out of young men who'd mutilated their uncle's jalopy. The last Zaporozhets came off the line in 1994, but as soon as the early 2000s the now-rare vehicles found a resurgence in popularity as collector's items and expensively modified Frankencars. Even Vladimir Putin showed off his 1972 ZAZ-968—unwittingly bookending an era set into bumpy, shaky motion by Khrushchev.

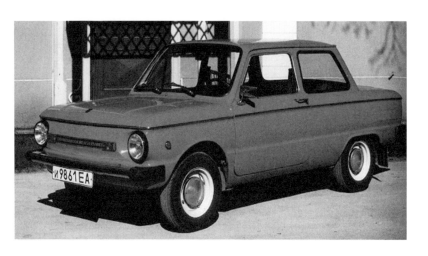

Za Rulem

"Behind the Wheel" tabletop driving game

Introduced in the 1970s to become an instant hit with the tricky demographic of Soviet boys, ages 6–30, Behind the Wheel is all about getting around the track—a track less than one foot in diameter. The tabletop console is set into action with the turn of the key in the game's ignition. (As with many actual Soviet cars, this could also be accomplished using a screwdriver.) The vehicle is then propelled around the track using advanced magnetic technology. Or, rather, the track is propelled around the vehicle: When the game is turned on, the road begins to revolve slowly, like a record player, hurtling obstacles— namely, bridges—at the driver. Those bridges stretch over the course with three forbidding arms, echoing the bars of the steering wheel as well as, perhaps, the Benz logo.

The only official variation in the game play was the track's increasing rate of rotation. (The unofficial: switching the polarity of the batteries threw the entire thing into reverse. You could also swap the car for any other metallic object, such as, say, a coffee spoon). On Level 3, it took everything the player had to keep the car from crashing headlong into bridge supports—the car by now furiously spinning like a bee in a jar. If you could go around more than five times in a row on Level 3, it was because you had lost your entire childhood to that game. Many did, and still do. Amazingly, Behind the Wheel is produced by the original manufacturer, the Omsk Electronic Goods Factory, to this day, and can be bought online for about thirty-five dollars. The current version, Behind the Wheel 5, adds remote-controlled gas and brake pedals. But the road still spins, and the brave little car still idles, frozen magnetically to the track as the world goes by.

Banki

Traditional instruments of homeopathic remedy

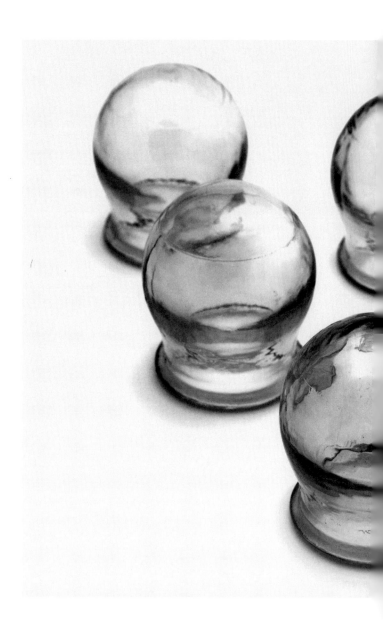

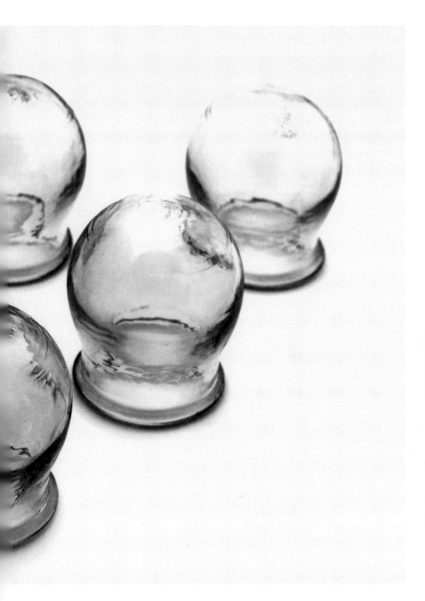

One of the most frightening words in the Russian language is *banki*, which nominally refers to the plural of a glass or a jar, but which the Oxford Russian-English dictionary also helpfully describes as "(med.) cupping glass." I'm not sure about the "med." part, because I've yet to meet any sufferer of asthma, pneumonia, or any other bronchial disaster that this insane form of peasant medicine has ever cured. As far as I'm concerned, the application of said "cupping glass" to the soft white back of a wheezing Leningrad boy in 1974 represented the culmination of three thousand years of not-so-great medical intervention beginning with the traditional practices of the Greeks and the Chinese and ending in a village in the little northwest Russian resort suburb of Sestroretsk, where I encountered the damn things as a toddler.

I was sick. Always sick. From birth to adolescence my lungs were like two deflated airbags pilfered out of a crashed Toyota and resold to a Mexican chop shop. At age two, even in a summer dacha, I was coughing myself nearly to death with what the local doctors labeled as "pre-whooping-cough inflammation of the lungs." They told my parents to go to a nearby river, where the water's humidity would make things better. After that brilliant advice failed to produce results, the next station of the cross was prescribed: *banki*.

This is what I remember all too well. I'm lying on my stomach. The *banki* are produced, they are little glass jars, greenish in tint, each probably the size of my tiny child-foot. My entire back is rubbed with Vaseline by my mother's strong hand. That action alone will probably keep me away from homosexuality for the rest of my life.

For an imaginative child used to the kind, simple love of parents and grandparents, what follows is frightening beyond belief. A pair of tweezers wrapped in cotton are soaked in vodka or rubbing alcohol and set on fire. The flaming pincers are then stuck inside the glass jar, which sucks out the air so that the edges of the "cup" will form perfect suction with the

skin. In one swift motion, the flaming pincers are removed from the now oxygen-less glass jar, and, with the sound of a horrible kiss, the cup is then stuck to the invalid's back, supposedly to pull the mucous away from the lungs, but in reality to scare the toddler into thinking his parents are raving pyromaniacs with serious intent to hurt.

Let me close my eyes... Yes. I'm hearing now a long match struck against the matchbox by Mommy—*ptch*—then the flames of the cotton-wrapped pincer as wild as a forest fire against the soft prism of my imagination, then the whoosh of air being sucked out as if by neutron bomb, then the sting of the warm glass against my back. And then ten minutes of lying still as a leaf at the bottom of a pool, lest the six or seven *banki* lining my tortured back pop off and the whole procedure be repeated. Even today I loathe to replace a burned-out light bulb because a *banka* so resembles a hollowed-out version of the same.

The first step of our multipart emigration to America involved a weeklong stopover in Vienna. I was seven years old and dying from asthma, as usual, and had to be taken to a Viennese medical clinic. Herr Doktor took one look at my black-and-blue-bruised back and prepared to call the police with a fresh report of child abuse. After my parents explained that it was merely "cupping," he laughed and said, "How old-fashioned!" or "How idiotic!" or "You crazy Russians, what will you do next?" He gave me something I had never encountered in the old USSR: a simple asthma inhaler. For the first time in my life I enjoyed the realization that I didn't have to choke to death every night. My parents continued cupping the crap out of me in America, there was no letting go of their belief in the flaming cotton pincers, the *ptch* of the long match, and the sight of their child in acute discomfort beneath a constellation of greenish glass. As for me, my lifelong love affair with Western medicine, from asthma inhalers to the latest class of anxiety meds, had only just begun.

Gary Shteyngart

Nevalyashka

Russian tilting dolls

Though not as famous outside of Russia as the *matryoshka* (aka the nesting doll), the Russian tilting doll, or *nevalyashka*, was the first toy for millions of Soviet babies. Its appeal is immediately apparent: round, red, and wobbly, the doll tilts, but never falls down. Push her around however you like, the *nevalyashka* will always get back up without losing an ounce of her composure or injuring an infant. On top of that, she jingles.

Tilting, or roly-poly, dolls are a staple in almost every culture. In Russia, they appeared as early as the beginning of the nineteenth century. The earliest examples in Russia were made of lacquered wood and looked like merchants, clowns, and circus girls balancing on balls. It was not until 1958, when the now iconic baby doll design was developed at the Sergiev-Posad Toy Research Institute, that the appearance of the dolls suddenly returned to its historical origin: the red and white Japanese Daruma dolls.

Daruma figures are the source of a Japanese proverb on persistence: "Fall down seven times, get up eight." Ovular and approximately the size of a basketball, the tilting Japanese dolls depict Bodhidharma, the Indian priest who brought Zen Buddhism to Japan. According to legend, Bodhidharma attained enlightenment after meditating without moving for seven years straight. The price of enlightenment, and the natural consequence of his stillness, turned out to be Bodhidharma's arms and legs, which fell off. Thus, the Daruma dolls show only his little white face in a big red hood. The neck, waistline, and those strange little nub "arms" are all Soviet innovations, as is the remarkably coy facial expression.

Ostankino Tower

Television broadcasting tower

When it comes to totalitarian governments erecting towers, size matters. Logic, less so. In the mid-1950s, Moscow had a legitimate need for a new broadcasting center. But the task immediately turned into another occasion for the display of Soviet might: A tower would be built in time to commemorate the fiftieth anniversary of the October Revolution in 1967. And the only proper way to do that would be to make it the tallest freestanding structure in the world. But how would this colossus, monumental in every sense of the word, stand? Nikolai Nikitin, the designer of what came to be known as the Ostankino Tower, had a very original answer to this question.

The tower's design is both simple and striking. It resembles an overturned lily, with its ten-petaled base rooted to the ground and its stem a hollow, 1,247-foot-long cylinder of reinforced concrete. The structure has a remarkably shallow foundation considering its total height, which is 1,771 feet. This is made possible by 149 steel cables that run along the inside of the tower's stem, providing its main support. It is said that it can withstand earthquakes up to a magnitude of eight on the Richter scale.

But the Ostankino Tower isn't just a pretty pillar. It hosts the majority of Russian television and radio stations and with a broadcast radius of about seventy-five miles, is responsible for nearly all the signals for the Moscow region. It also houses a number of government communications centers, a concert hall, and, of course, a now-closed three-story revolving restaurant called Seventh Heaven (Sed'moe Nebo). The slightly surreal eatery made a full journey around the tower's axis once every forty minutes, and saw more than ten million customers during its thirty years in service.

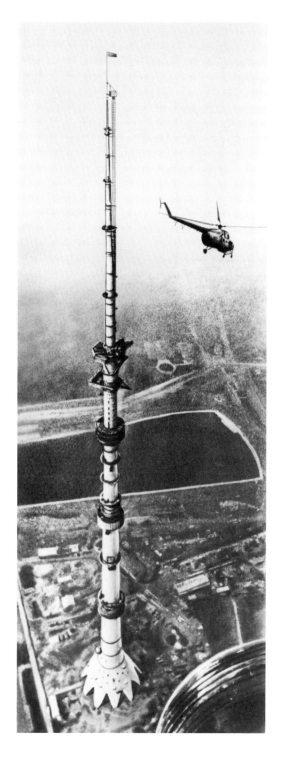

On top of all this, the Ostankino Tower is rather spooky. The neighborhood of Ostankino is said to be the site of an ancient cemetery, as well as a dumping ground for the bodies of suicides. The very name Ostankino is directly related to the word "*ostanki*," which means "remains"—as in, human ones. Some say the tower is haunted by "the hag of Ostankino," the ghost of an old woman who appears periodically in order to foretell disasters. The Russian hit movies *Night Watch* and *Day Watch* capitalized on this by making the tower the setting for a battle between the forces of light and darkness.

Superstitions surrounding the tower found their justification when a fire devastated the structure in August 2000. During the fifteen-hour blaze and in its aftermath, nearly all television broadcasts in Moscow were cut off. The fire was caused by an overload of wires, piled on over the years as the demands on its capabilities had increased. The tower is still in working order; however, of the 149 steel cables that were its main source of support, only nineteen remain. As for the title of the world's tallest structure, it only held that for four years: In 1971, Toronto's CN Tower snatched it away.

Misha

1980 Moscow Olympic mascot

As a national symbol, the Russian bear is often characterized by Westerners as brutal, stubborn, and clumsy. However, in their own folklore, Russians consider the bear powerful but friendly, an emblem of benevolence and homey comfort. When the time came to decide on a mascot for the 1980 Moscow Olympic games, there was no question which creature would be chosen. The results of a poll conducted jointly by the popular television nature show *In the Animal Kingdom* (*V mire zhivotnyh*) and the newspaper *Soviet Sport* (*Sovetskii sport*) confirmed this choice to the tune of forty-five thousand letters, all in favor of a bear.

In 1977, to pick a design for the mascot, the Olympic committee conducted a contest among Soviet artists, who were told simply to "draw bears." The illustrator Victor Chizhikov won with his adorable brown cub, who wore a belt with the Olympic rings as a buckle. With the great flight of imagination that typically accompanies the naming of bears in Russia, the committee went with "Misha," the Russian diminutive for both the name Michael and the word for "bear." Now, Mikhailo Potapych Toptygin (the full name given Misha by his creator, replete with onomatopoeic puns on stomp) was ready for his close-up.

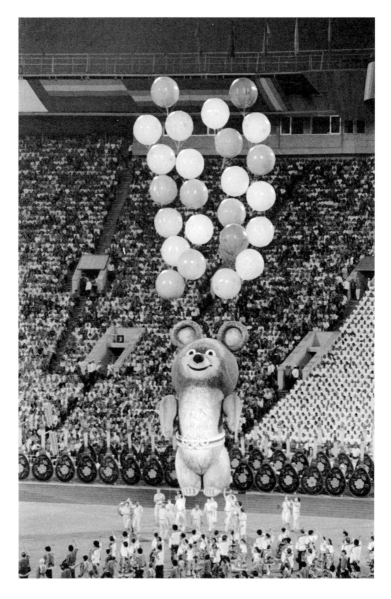

Considering their general lack of branding know-how, the Soviets were surprisingly good at merchandising Misha. Not only was he to be seen on every imaginable type of object manufactured in the Soviet Union at the time and stamped on every surface in Moscow, he ended up getting his own television show. The Misha phenomenon made him the first mascot of a sporting event to achieve such wide-ranging success as a brand. In this, Misha set the bar pretty high—arguably, no Olympic mascot since has been quite as universally recognizable.

During the games themselves, Misha appeared as a giant balloon that was released during the closing ceremonies as a cartoon version of him shed tears on a screen and a choir of children sang "Good-bye, our sweet Misha." There was not a dry eye in the stadium. One can only imagine the tears that the mascot's further fate would elicit: The balloon was recovered on the outskirts hours later, and put in storage where it was abandoned to be devoured by rats. Though his body left this Earth, Misha's spirit lived on to welcome Mickey Mouse to Moscow in honor of the latter icon's sixtieth birthday celebration in 1988. There is talk of reviving Misha once more, for the 2014 Winter Olympics in Sochi. It will be interesting to see whether the old cub still packs the same merchandizing punch in the free market—and whether this time around, the rest of the world will finally succumb to the charms of the Russian bear.

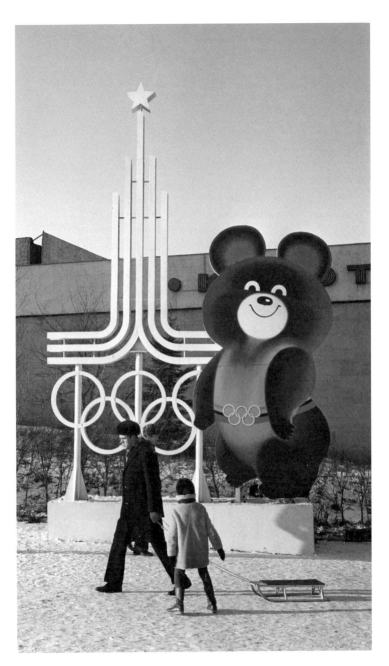

Lototron

National lottery machine

At first glance, Communism and gambling don't seem like they would mix. However, almost immediately after the Revolution, the Soviet government began using lotteries in order to generate income they couldn't have gotten anywhere else. In 1970 the Soviet Union's Committee on Sports created Sportloto, a national lottery game with cash prizes. The actual Loto, a Russian version of bingo, was already a popular board game, played only for the thrill of covering a row of numbers first. By contrast, winners of Sportloto would receive sizeable cash prizes and, later, their choice of either cash or a car.

The televised presentation of the game's climactic moment—the unveiling of the winning numbers—followed in 1974. It was given a full-on Hollywood treatment, complete with comely presenters and an instantly fetishized number-ball rolling machine called a "lototron." The lototron's transparent top was a roiling sea of golf-size balls, jumping around like popcorn in a popper, until six winners traveled one by one down a metal chute and came to rest cheek to cheek at the end of it; at which point a well-groomed female hand sensuously tweaked each, so the number would face the camera. Ecstasy!

In order to partake in all this glitz, people would purchase game cards at special kiosks. At first, the cards were seven by seven, which was later changed to six by six, and, finally, to cards where the player had to cover six out of forty-nine squares. The odds of winning Sportloto were so astronomically low that game regulators were forced to adjust the rules every few years in order to make it seem like it was getting easier to win. Despite this, Sportloto was so popular that proceeds from the game alone were enough to fund the 1980 Moscow Olympics.

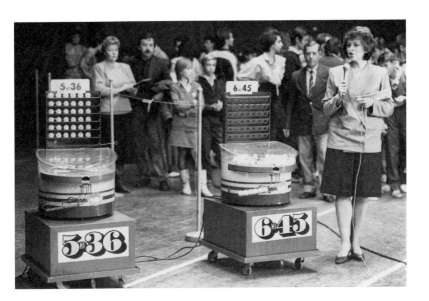

Mishka Kosolapyi

"Clumsy Bear" chocolate bar wrapper

It wasn't until the week my grandfather died that I had a good look at photographs from the prime of his youth—before he saw action during the Siege of Leningrad, a radio strapped to his back; before Jewish quotas forced him to scrap his academic ambitions; before he got into trouble for practicing the only white-collar trade he could—business management—which happened to rely on a thriving black market. In washed-out black-and-white photos with scalloped edges, this Soviet Man was compact and taut, handsome with a stern, piercing stare. In my living memory, Dedushka was eloquent but diminished, wry but visibly embittered. (Though, as the only member of my family claiming intellectual status, he was my idol.)

Yet he told the same stories to his grandchildren that he'd honed a quarter century earlier for his two daughters. My mother and aunt remember them little better than I do, but we all know they concerned a certain Mishka Kosolapy—translation: "Clumsy (or Pigeon-toed) Bear." Mishka was a well-meaning but bumbling creature, whose misjudgments led to Aesopian lessons. Goofus combined with Zelig, he would also go places my cousins and I had never heard of—never mind Dedushka's own children, huddled on the daybed in their drab Kishinev flat, where Leningrad was just a rumor. The only specific mishap I remember is Mishka swallowing an entire watermelon, presumably demonstrating the consequences of gluttony.

Only later did I learn that my grandfather's impromptu tales drew on deep Russian source material. Just four subway stops away in Brighton Beach, variety stores were selling candies bearing Mishka's name. "Mishka Kosolapy" was branded in 1925 by a candy company that had long been called Einem, after its German immigrant founder, but had recently been

rechristened Krasny Oktyabr. (Thus Russia's two most successful German imports—chocolate and Communism—were joined in solidarity.) "Mishka" was their first signature animal chocolate. Today, the Clumsy Bear and his imitators (such as "Three Bears" and a tasteless, stale American counterfeit known as "Miska the Bear") proliferate alongside "Squirrel," "Camel," "Bird's Milk," and dozens of other chocolates containing praline, wafer, chocolate, hazelnut, and marshmallow in various textures and combinations.

The Clumsy Bear is not the tastiest of Russian chocolates (most prefer the softer, sweeter Squirrel), but you could argue that it's the most quintessentially Russian. The illustration on the cover features a triangular arrangement of bears, three of them cubs, balancing on cantilevered pine trunks. Set in a rounded rectangle over a field of bright blue, the image is a foreshortening of one of Russia's most popular paintings, Ivan Shishkin's *Morning in a Pine Forest* of 1889. A landscape painter of the high establishment, Shishkin—like Pushkin—is one of the few Russian artists whose reputations survived the Soviets unscathed. An asteroid was named after him in 1978.

The name "Mishka Kosolapy" has a fuzzier and folksier derivation. Every Russian child has at some point memorized the following (clumsily translated) poem:

> Mishka Kosolapy through the forest roams,
> Sings a little song and gathers up pinecones.
> One of them tumbled right onto Mishka's head,
> So Mishka got mad and stomped the pinecone dead.

The coincidence of a classical painting and a nursery rhyme was tailor-made for a candy maker intent on creating its own icons—in a period before what we now know as "branding" was completely co-opted by the Party. It dovetails, too, with Russia's own icon, one it has at times defiantly resisted: the bear.

The bear of both poem and painting is somewhat tamed: Mishka and the cubs are cute and fuzzy (though Shishkin's

Mama Bear roars protectively) and their milieu is positively Arcadian. But the traits that Dedushka teased out for his didactic improvisations were Mishka's familiarity and his inadvertent destructiveness. When he wasn't spinning animal tales, my grandfather was a disciplinarian, the enforcer of a rigid moral code built largely on family loyalty. He learned to live by Soviet rules, but he passed on to his children a deeply cynical attitude toward a government that, he believed, had deprived him of opportunity at every turn. (Which is probably why my aunt likes to quote Bill O'Reilly, but that's another story.)

In the United States, Dedushka stood out like a pigeon-toed bear—even within the family circle. He was given to longer and longer monologues, replete with conspiracy theories and political paranoia, that were equal parts wisdom and scattershot anger. The fact that all his theorizing was harmless— that he really was just stomping on pine cones—only made things worse. Dedushka had always thought himself a writer manqué, and in the 1990s he finally gathered some thoughts into a book. An autobiography randomly padded with family tributes, poems, and nursery rhymes, it was the sum total of his stories, and he only had one chance to get it down between covers. It was called *Stolen Life*. The sketchy line drawing a relative made for the cover endows him with a Rabbinical look—rather appropriate, because his written Russian was a dialect studded with the Yiddishisms of his childhood. This Soviet Man was even more alienated than I'd thought. And yet he'd learned how to live, and to raise and educate his children, only to wash up on another shore, in a populist meritocracy where no one spoke his language. He had himself become an artifact, like the stories he carried with him from one false utopia to the next, and like the snatches of rhyme and legend and crispy wafer that somehow made it from Imperial Mitteleuropa to latter-day south Brooklyn. The clumsy bear of the Soviet Union is gone, but he left some cones behind.

Boris Kachka

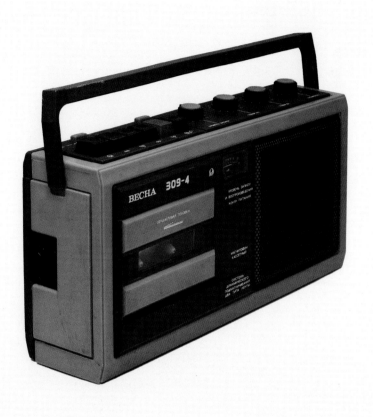

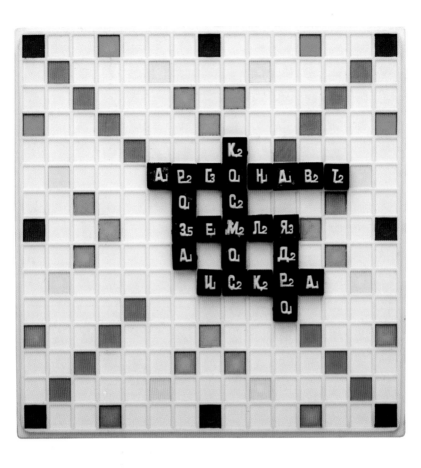

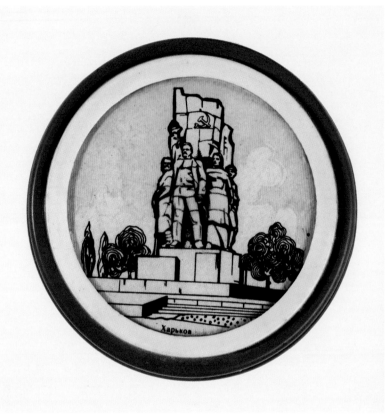

АЭЛИТА-2

ФЕН

ГОСТ 22314-77 льное напряжение 220 В ~ 50 Гц

Тип. № 32. Зак. 670—100 000. ебляемая мощность 330 Вт

Цена — 22 руб.

113184, Москва, Средний Овчинниковский пер., 5.

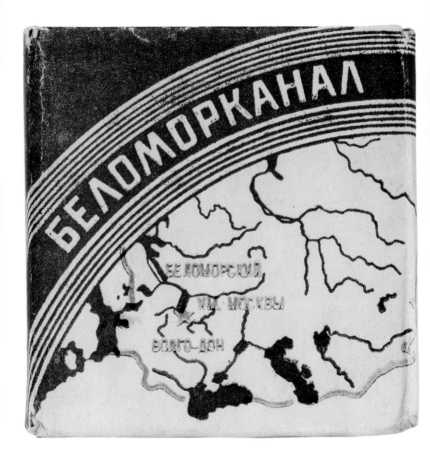

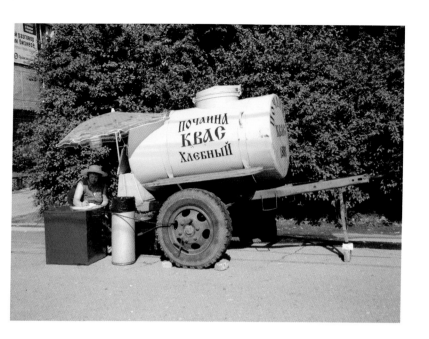

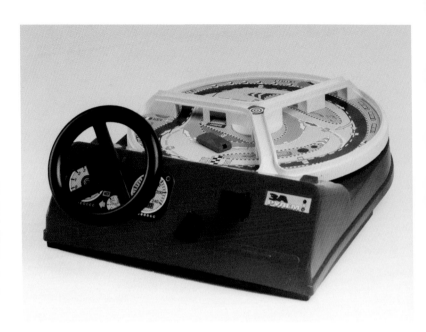

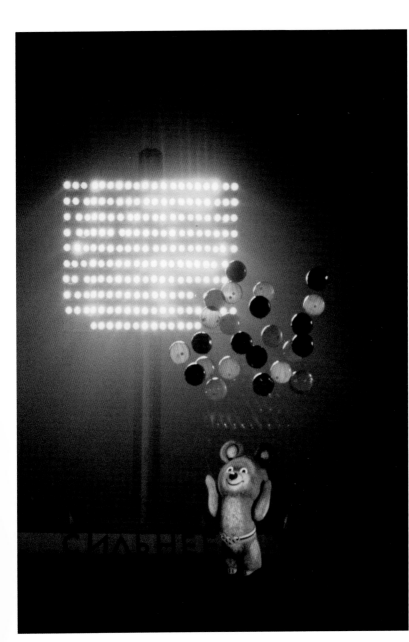

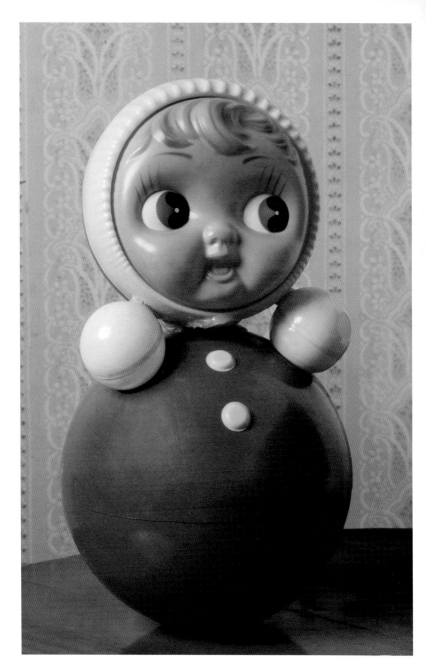

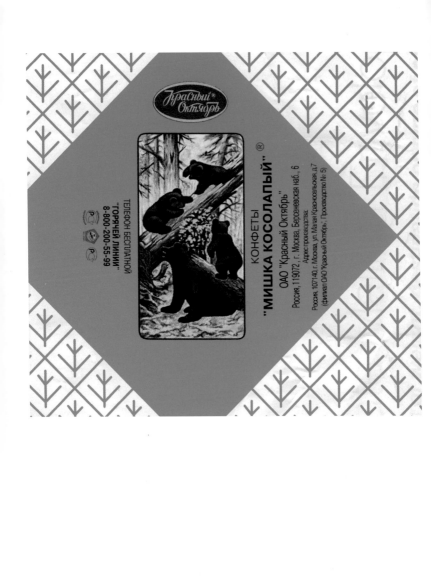

Красный®
Октябрь

КОНФЕТЫ
"МИШКА КОСОЛАПЫЙ" ®

ОАО "Красный Октябрь"
Россия, 119072, г. Москва, Берсеневская наб., 6
Адрес производства:
Россия, 107140, г. Москва, ул. Малая Красносельская, д.7
(филиал ОАО "Красный Октябрь", Производство № 5)

ТЕЛЕФОН БЕСПЛАТНОЙ
"ГОРЯЧЕЙ ЛИНИИ"
8-800-200-55-99

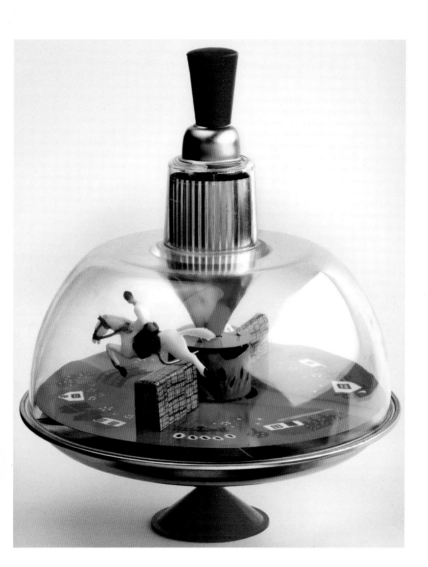

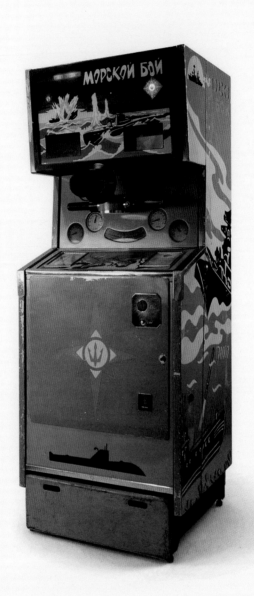

VEF Spidola

Portable wireless transistor radio

The Spidola, first manufactured in Latvia in 1962, was one of the first transistor radios widely available in the USSR. Its relatively high cost did not stand in the way of its popularity. In fact, by the late 1960s, its name had become synonymous with radio. Light and small, for a time it was the only portable musical device in the country: No longer would the nation suffer through a picnic in silence.

But the fact that it brought state-controlled radio outdoors wasn't the reason to love it. What launched the Spidola from fame into notoriety was how quickly it became a portal to forbidden radio transmissions from the West. The generation of Soviets coming-of-age during the cultural "thaw" of the 1960s used their Spidolas to listen secretly to Radio Free Europe and Radio Liberty. Though the signals were often jammed and the danger of being caught with an ear to the enemy unmitigated, the people's yearning for free press and rock and roll could not be suppressed. In one court case in 1971, a Spidola belonging to a Soviet dissident was even confiscated as an "instrument of crime." The innocuous-looking little box was acknowledged as a weapon for fighting oppression.

Its classic design survived almost unchanged through the eras of the Beatles and White Snake, until it stopped being manufactured in the early 1990s. Though a multitude of other makes and models may since have rendered it obsolete, it will always be remembered for living up to its name: in Latvian, "*spidola*" means "the shining one"—the source of light.

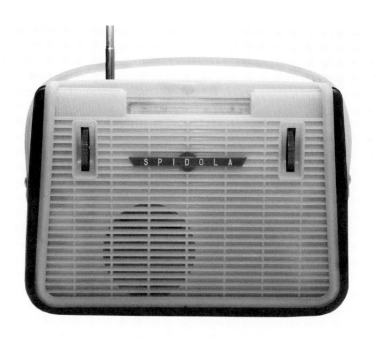

Vyatka

Motor scooter

After World War II, Italy found itself with a crippled
economy, a ravaged infrastructure, and severely restricted
manufacturing capabilities. Piaggio, a family-run aeronautical
manufacturer, turned this situation into an opportunity.
Enrico Piaggio, the son of Piaggio's founder, decided that
what Italy needed was a new, affordable mode of
transportation. He commissioned the aeronautical engineer
Corradino D'Ascanio, the inventor of the first modern
helicopter, to come up with a different kind of chopper—
the motor scooter. And the rest is Vespa history.

Meanwhile, the very same problems plagued the post-war
Soviet Union. However, it took the Kremlin until 1956 to
begin dealing with them. Long before, Lenin had promised
that the typical Soviet citizen would be able to afford
a means of personal transportation for the price of two
paychecks. The fulfillment of this promise was long overdue,
but the timing proved convenient. The world had already
seen the now-classic 1955 Vespa 150 GS when the Soviet
government gave its engineers a six-month deadline to
replicate it. Surprisingly, this proved enough time to
produce the Vyatka, the best Soviet knockoff ever devised.

The Vyatka was produced by the Vyatsk-Polyansky
Mechanical-Engineering Plant, which, in its two decades
of existence, had already manufactured textiles, machine guns,
and gramophones. At first glance, the scooter stole
everything from the Italians, including a five-letter name that
starts with a V and ends with an A, and even the font in
which it's written. And yet some Soviet je ne sais quois has
found its way in. It was slower, heavier, squarer than its zippy
prototype—in other words, more Russian. This also made

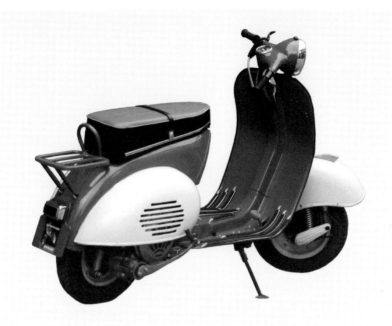

it better suited to the harsher climate and terrain, not to mention the Soviet roads. Its makers were so proud of their copy that, in 1960, they slapped a little red flag with a star on it in the same place the original had its Italian flag.

And they had something to be proud of. For about a sixth of the cost of the cheapest available car (see page 150), there was now a reliable vehicle available, as Lenin had promised, to every Soviet citizen. Unfortunately, it never really caught on. You couldn't ride it in winter, and it wasn't powerful enough to be of real use in rural areas. Around the same time, another scooter, based on the German Goggo TA200, was also being developed in Tula. The more powerful Tulets and its progeny took off in the countryside. Even today, you can still see farm workers using it to tug trunks full of livestock along Russia's dirt roads. As for the Vyatka, after some 1.5 million scooters, including a 1975 model with an electrical ignition stolen from a Yamaha, new models stopped being produced in 1979.

LOMO

Instant camera

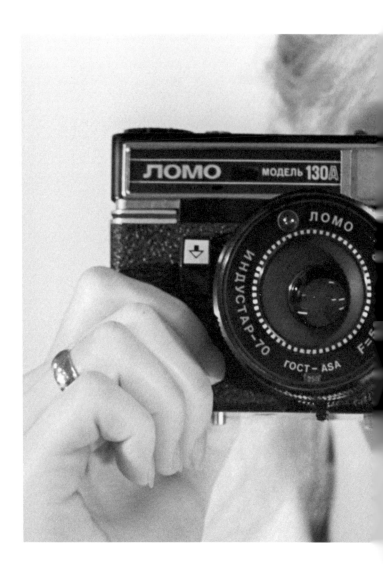

The LOMO camera and the soft, vivid photographs it takes are now an artistic cliché. The famous name unfolds into "Leningrad Optics and Mechanics Amalgamation," after the factory that produced it. But the original LOMO, a copy of a Japanese Cosina CX-1, was designed for use in the espionage industry. The Ministry of Defense, however, decided that the images it produced were insufficiently detailed, and that the camera, which weighed about as much as a pack of cigarettes, was too heavy. So they released it to the people. First mass-produced in 1984, the LOMO was instantly and wildly popular for the same reasons it is popular now: compact, affordable, and romantic. Responsible for that last was the Minitar-1, the only 32-mm multicoated wide-angle lens that allowed the camera to be used in a wide variety of light conditions, and which produced the signature vignetting and deep, washy colors.

After 1991 the LOMO could not compete with the influx of cheaper imports from Asia, and production died off— until two Austrian students came across one at an antique camera shop in Prague and found themselves so enamored that they began smuggling LOMOs out of former Soviet republics for distribution in the West. They founded the Lomographic Society and gave it a catchy motto: "Don't think, just shoot." In 1994, the Society invited the heads of the LOMO company to a dual Lomography exhibition in Moscow and New York. Their invitation was dismissed as an April Fools' joke. The manufacturers realized the blunder only after the Moscow show received major television coverage, and soon gave the Austrians sole distribution rights for their product outside of Russia. Then, less than two years later, they stopped production of it. The Lomographers wouldn't give up, and wrangled members of the Austrian parliament into a meeting with the Deputy Mayor of St. Petersburg, one Vladimir Putin. Putin placated the company with a tax break and, in the process, befriended its president Ilya Klebanov, who became his Deputy Prime Minister in 1998. So next time you capture a sunset at the skate park, remember, you owe your freedom not to think and just to shoot almost entirely to the KGB.

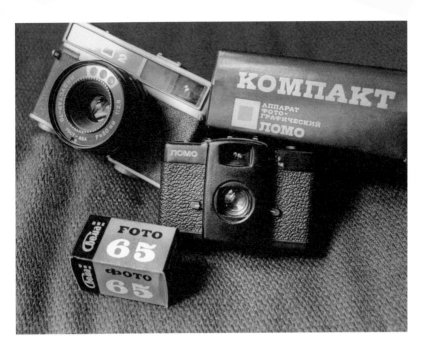

RIA Novosti

Logo of the renowned Soviet news agency

As one of the final strokes of Soviet design, this original 1991 logo of RIA Novosti, the most-quoted Russian news agency, is the youngest item in this book. The agency itself was created in 1941 as the Soviet Information Bureau, or *Sovinformburo*, and tasked with reporting from the front lines of the Second World War. The bureau's reports appeared in nearly two hundred newspapers, hundreds of magazines, and eighteen radio stations in twenty-three countries—numbers that only increased through the organization's progressive expansion into book publishing, television, and the publication of its own newspaper, the *Moscow News*. In 1961 it was renamed the Novosti Press Agency (APN) and in 1990, the Information Agency Novosti (IAN)—a name it held for a year until, with the Soviet Union's future in grave doubt, someone tacked the word "Russian" onto it.

The RIA Novosti logo is thus a willful departure from some heavy history, and the agency's first attempt to show how its reach and experience prepared it to become a real, objective, global news organization. It may not look like much right away, especially to a viewer unused to Cyrillic. But look: the Russian letters *R*, *I*, and *A* can be read diagonally left to right, but also back from the lower right corner, right to left.

The RIA ambigram perfectly summarizes the ultimate aim of any news agency: to be a wire incessantly transmitting essential information between any and all geographical endpoints. It's also a tacit admission that news can be interpreted in different ways. In the center of the logo, we find a dynamic ellipse—the form of a circle in motion, like the equator seen from the side. It could be argued that this is the perfect use of an ambigram—to convey motion, globality, dialogue. It is a pity that the post-Soviet RIAN didn't think so, and changed their logo to something much tamer and more banal (a three-dimensional globe) in 2007.

Vertushka

Dialless diplomatic telephone

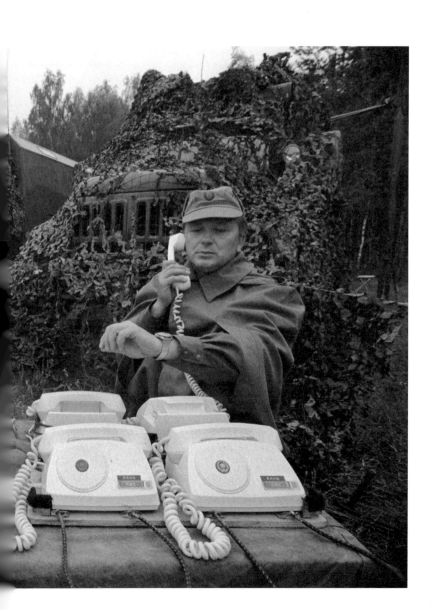

The ultimate Soviet status symbol—beyond a black Chaika sedan, a government dacha, or a French stamp in the passport—was a lowly telephone. The only difference between a vertushka and any other phone was its conspicuous lack of a dial. You didn't need one: having a vertushka meant people called you. Important people. Some vertushkas belabored the point by affixing the Soviet emblem where the rotary disk would have been. But the blank-faced ones somehow looked even more impressive, testifying mutely from the corner of a desk to the lucky owner's literal Kremlin connection.

Vertushka means "spinner;" the name is a result of semantic drift. When Lenin ordered the installation of the Kremlin's first switchboard in 1918, all actual dialing was done by an operator. Only conversations between the highest-placed Bolsheviks were conducted by direct dial, to avoid an extra pair of ears on the line, and so a select group received their own "spinners" and three-digit numbers to go with them. (Felix Dzerzhinsky, the creator of the Soviet secret police, was issued the number 007.) The manual for the "auto-telephone" patiently instructed the user "not to wait for the operator, as there is nobody there." Decades later, an open line with with a human go-between would be a greater luxury than a rotary dial, but by then the name had stuck.

By 1922, vertushkas connected to the central switchboard began to pop up outside of the Kremlin, in the homes and offices of the new elite, and the word eventually came to refer to any direct line to the government. There existed two separate circuits: ATS-2 connected mid-size players, such as the secretaries of regional party committees; ATS-1 was reserved for the Politburo, ministers, and top military brass. Only the owner of a phone had the right to pick it up. The call was thus a privilege not to be abused. In the 1990s, this gentlemen's agreement was among the first to be flouted by Russia's new rulers, who blithely moved the vertushkas to their aides' desks. Not until 2008, when president Medvedev brandished the (still officially unavailable) iPhone, would a telephone carry this much political juice in Russia.

Khryusha and Stepashka

Children's television icons

Good Night, Little Ones! (*Spokoinoi nochi, malyshi!*) is one
of the world's longest-running children's programs. The ten-
minute show has aired at 8 pm since 1964, overexciting
several generations of little ones and inevitably delaying
their bedtimes. The show's winning formula is an unbeatable
combination of puppets, cartoons, and pat moral lessons.
At the heart of it all are two charmingly crude puppets:
Khryusha ("Oinker"), a somewhat mischievous piglet,
and Stepashka, a more reasonable rabbit. Along with their
friends, Filya the dog and Karkusha the (female) crow,
the duo find themselves constantly in the midst of various
moral predicaments. Luckily, there is an adult host
on hand to impart wisdom and reward the beasts with a
cartoon. The show ends with a tender lullaby set to even
more tender claymation, a piece of music that has the
Kryptonite-like power to bring absolutely every Russian
below the age of fifty-five to instant tears. (Please use this
knowledge responsibly.)

The puppets remained unchanged for decades—no small feat
considering they were clearly handmade. In the meantime
they managed to worm their way into the nation's psyche
like no other Soviet pop icon, with the possible exception of
Misha the Olympic Bear. In the 1980s, for instance, spirited
national discussion surrounded the fact that, unlike the
other puppets, Khryusha didn't blink. The show was taken
seriously enough that at least two episodes got pulled

off the air for political reasons. The first one coincided with a state visit by Castro, and was forbidden because Filya the dog's name was considered a bit too close to Fidel. The second, more famous instance occurred soon after Mikhail Gorbachev came to power. The censors nixed an episode featuring a cartoon about an indecisive bear who never finishes anything he starts. (The bear's name, like that of all Russian bears, was Misha, a popular diminutive of Mikhail.)

Since the fall of the Soviet Union, the show has struggled. To keep its quaint time slot, which turned out to be right in the middle of prime time, it's been hopping from network to network. Its iconic status is still intact, though, and so are the puppets. When the producers decided that *Good Night* should become more educational, with Khryusha and Stepashka teaching children the alphabet, many adults were genuinely upset at the change; perhaps some were placated by the fact that the show is now hosted by the former Miss Universe, Oksana Fedorova. There is also some worry that the puppets have taken too strongly after their Western counterparts. In recent times, Khryusha and Stepashka have been seen shilling for Pampers and pedagogical English-language DVDs. All bets are off on whether *Good Night* will survive long enough for them to start rapping.

Horse and Jockey

Spinning top

The Horse and Jockey spinning top whirled into Soviet homes in the 1950s. It was made at the Red Proletariat Factory (is there any other kind?) and quickly became a hot commodity. In fully functioning models, the horse even neighed as it cleared the obstacles blocking its course around the silvery dome. The rider sat proud. Above them, a Soviet baby sat mesmerized.

Spinning tops were a common first toy for infants, but this one had adult fans as well. In 1975, the tale of the top received an odd twist: The toy became an iconic part of the Soviet Union's most popular televised quiz show, *Chto? Gde? Kogda?* (*What? Where? When?*). (An American version of the program is now in development, presumably under a less panicky name.) Modified with the addition of an arrow, the top functioned as a spinner determining which question is asked of the players; it turned in close-up to the sound of a Russian Dixieland tune called "Wild Horse." This highly unusual product placement has helped keep the Red Proletariat Factory in business through the fall of the Soviet Union. Thus spun, the galloping horseman and his neighing companion keep spinning.

Motorcycle and sidecar

After the Blitzkrieg in Poland, Stalin understood that the
Red Army would need getaway vehicles. The outdated and
poorly made motorcycles the Soviets had used in their brief
conflict with Finland were not going to cut it. Since they
needed to work fast, the Russians decided to copy the
BMW R71 motorcycle, for which they had gotten drawings
and casting molds as part of the Molotov-Ribbentrop non-
aggression pact. (According to another story, after Stalin had
approved the BMW R71 as the best possible vehicle to
fit the army's needs, the Soviets bought five of these bikes
through a Swedish intermediary, smuggled them back to
Russia, and reverse-engineered their version.) Either way,
the Soviets wouldn't be shy in using the Nazis' own weapons
against them. In 1941, production of the Russian M-72
sidecar motorcycle began at a factory outside Moscow.

However, as Nazi troops were barreling their way toward the
Soviet capital, strategists worried that the Moscow plant
was too close to the front lines. Irbit, a former trading hub
on the edge of the Siberian steppe, was chosen as the new
location for the motorcycles to be built. Engineers hastened
to develop a new production complex, working out of
Irbit's former brewery. By 1942 the first M-72 motorcycles
emerged from the shadows of the Ural mountains and
rushed into battle.

The motorcycles unquestionably played an important role
in the Soviets' victory. The machines are sturdy, mean,
and powerful. There are areas in Russia still that can only be
accessed either on horseback or M-72. After the war,
production of the military motorcycles moved to a factory
in Ukraine, and the Irbit Motorcyle Works (IMZ) started
producing a civilian model—the same two-wheel drive,

minus the sidecar-mounted machine gun. They were named Urals, after the mountains in whose shadows they were designed, and proved so popular that in the 1960s IMZ converted to exclusively nonmilitary production.

The Soviet Union even started exporting these heavy-duty vehicles, mostly to developing countries. By the late 1960s, they had started appearing in the First World, where riders were taken by the Ural's stylish grit and durability. It was these Western Ural lovers who saved IMZ from going the way of the Soviet Union in the 1990s, when the company was on the brink of collapse for lack of state funding. Today, Europe and North America are the biggest customers for the retooled retro models of the bike, the custom-made Wolfs, and a few sleeker solo vehicles designed with a less punishing terrain in mind than Russia's.

New Russian Urals are of much higher quality than their Soviet predecessors, made from better metals, paints, and chrome, and using refined casting and alloying techniques. However, they still require about one thousand miles on them to be properly broken in, and riders can expect stiffness and difficult gear shifts from a brand-new bike. Riders must also be cautious around tight turns, since turning with an empty sidecar sometimes results in a brief transformation of the Ural into a flying machine. But no matter how rough the Ural is around its edges, there is no better vehicle for roaring down rural roads and pretending you're off to kick some Nazi butt. Except for maybe a tank.

Buran

Snowmobile

Snowmobiles have existed in Russia since the beginning of the last century. The first ones appeared almost immediately after the development of the compact internal combustion engine: putting a motor on skis seemed like a natural thing,

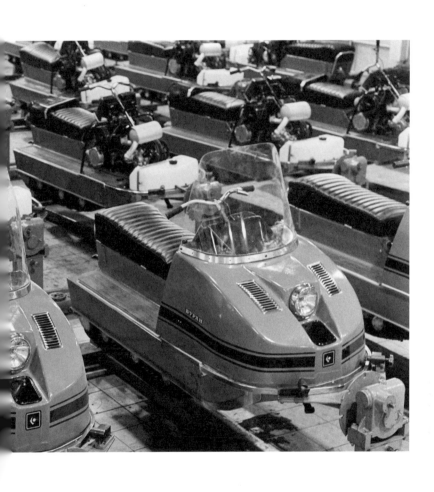

given the climate. One early model delivered mail. During the revolution and later in World War II, Soviet snowmobiles evolved into military vehicles. Bounding across icy expanses, only these "little tanks," as they were called, were capable of accomplishing logistical missions when everything else would slip on the ice or sink in the snow. In the 1930s they emerged as essential instruments in Arctic exploration, used to carry supplies and, every so often, rescue a scientist. But they weren't available for purchase by snowbound civilians.

This all changed in 1975, when an aviation and automotive factory in the city of Rybinsk cranked out the first Burans. The Buran was named in honor of a special kind of blizzard only seen on the steppe, perhaps as an allusion to the furious wake it left. (Later, the name would be appropriated for the Soviet version of the space shuttle.) Most foreign-made snowmobiles had, and still have, one tanklike track and two skis in front; the Buran reversed that ratio. This optimized maneuverability while making obstacles like pine branches or snow-covered tree trunks less liable to snag on the machine. In addition, the Buran actually balanced better: with one ski in front, no one side was favored when the rider was making turns. Still, this was no Vespa, or even Vyatka (see page 196): sturdiness and the ability to start in -30C were paramount. The instruction manual helpfully suggested "rocking the machine side to side" when the tread was frozen to the ground.

The Buran's comfort speed was 15–20 miles per hour across a snowy plain. Braver souls took it joyriding over the frozen rivers and lakes, where it easily topped 50 miles per hour over ice. Crazy customizing naturally ensued, and most of it involved grafting spare parts from Soviet cars onto the machine (luckily, it was designed with some generosity in that respect: it accepted spark plugs from the Zhiguli sedan, for instance). Like that sedan, the Buran is still being produced; a new one costs a respectable $2,500. Unlike the Zhiguli, however, you're unlikely to see one in Cuba or Egypt.